Modigliani

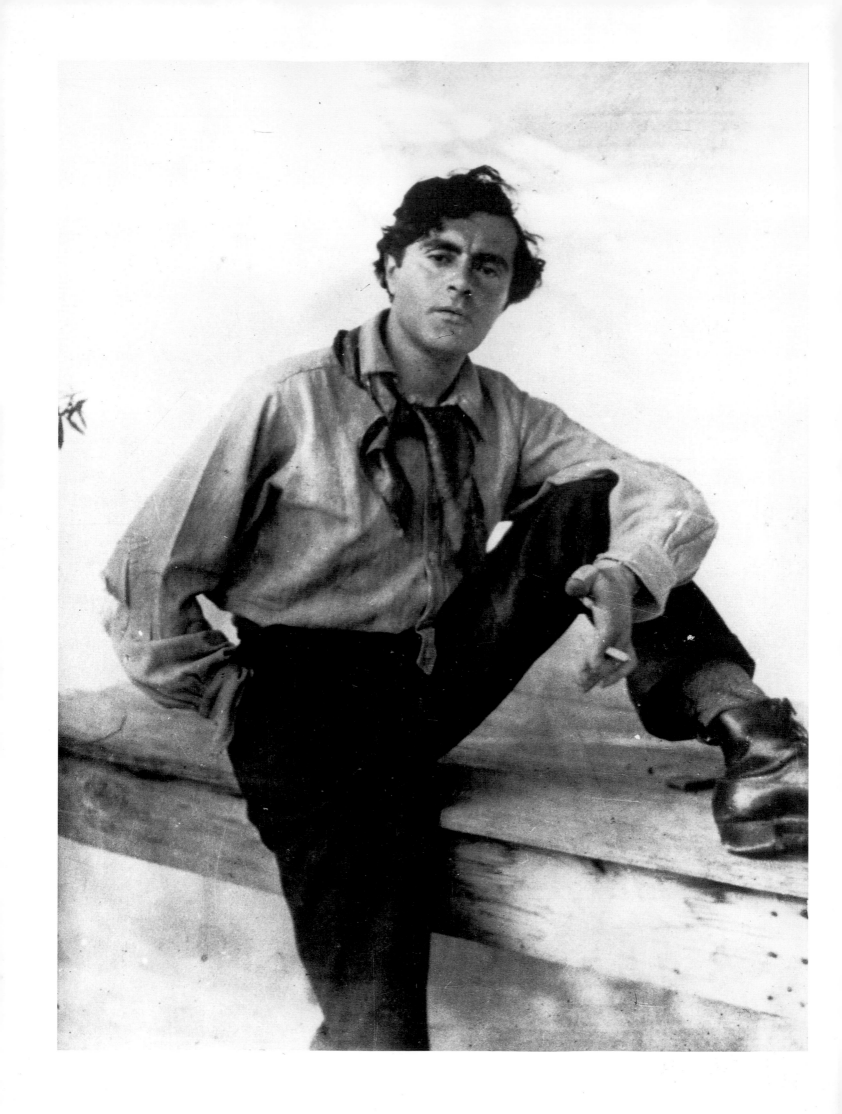

Doris Krystof

AMEDEO MODIGLIANI
1884–1920

The Poetry of Seeing

KÖLN LISBOA LONDON NEW YORK PARIS TOKYO

FRONT COVER:
Reclining Nude (detail), 1917
Oil on canvas, 60 x 92 cm
Ceroni 196
Stuttgart, Staatsgalerie

ILLUSTRATION PAGE 1:
Caryatid, 1913/14
Chalk on paper, 55.8 x 45.2 cm
Lucerne, Sammlung Galerie Rosengart

ILLUSTRATION PAGE 2:
Amedeo Modigliani, c. 1915

BACK COVER:
Amedeo Modigliani, c. 1906

© 1996 Benedikt Taschen Verlag GmbH
Hohenzollernring 53, D–50672 Köln
© 1996 VG Bild-Kunst, Bonn, for the illustrations of:
Constantin Brancusi, Jean Cocteau and Moïse Kisling
© 1996 Succession Picasso/VG Bild-Kunst, Bonn, for the illustrations of Pablo Picasso
© 1996 Dr Wolfgang & Ingeborg Henze-Ketterer, Wittrach/Berne
for the illustration of Ernst Ludwig Kirchner
Layout: Gilles Néret, Paris
English translation: Christina Rathgeber, Berlin
Cover design: Angelika Taschen, Köln

Printed in Germany
ISBN 3-8228-8641-6
GB

Contents

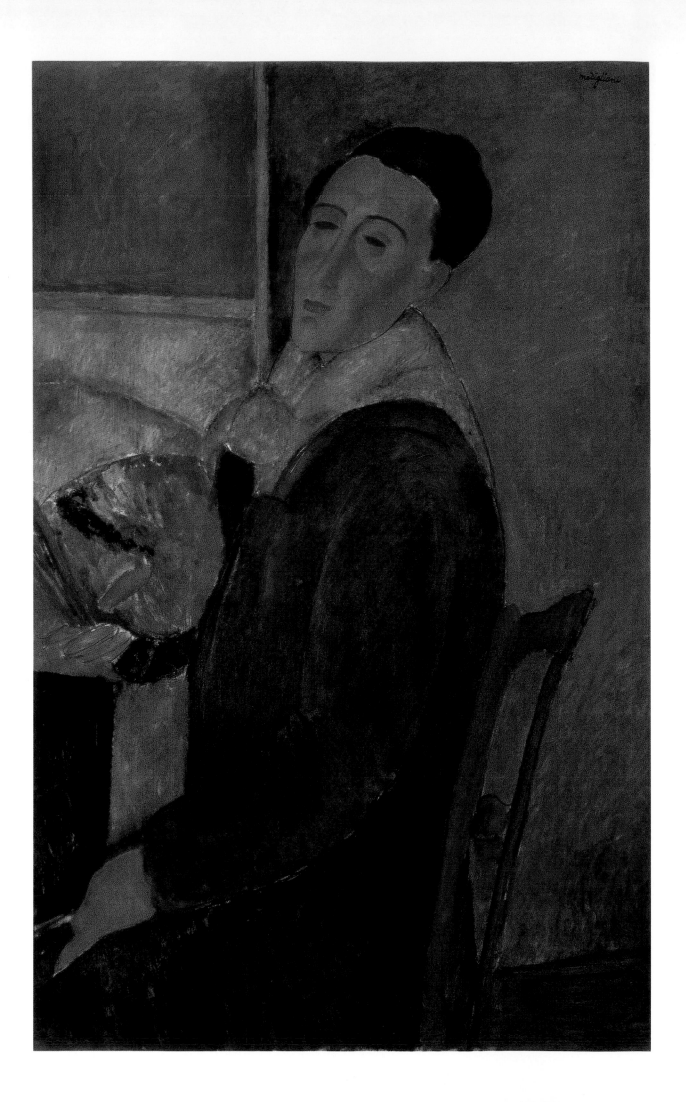

Fruitful Ideas

Perhaps it is the name. Amedeo Modigliani – it sounds like an elegiac melody, like a well-chosen name for a tragic, poetic figure in a novel, and perhaps it also has something to do with the fact that Modigliani, who has always fired the imagination, was not a figure who called forth factual and sober description. And this sensual-sounding name is not even a pseudonym. Amedeo Modigliani is the name of the artist who was born on July 12, 1884, in Livorno (Leghorn), Italy, into a bourgeois Jewish family. His portraits and nudes were to become some of the most popular pictures of the twentieth century. No other painter of modern times has been as heavily burdened with as many legends, myths and clichés as Amedeo Modigliani. Novels and a play have been written about him, his Bohemian lifestyle has been excessively idealised in films, and art criticism is also full of glorifying anecdotes. In contrast to all of this is the very small number of authenticated documents about Modigliani's life, so that it really is not easy to recognise the true Modigliani under all of these fiction-like features. Entwined with the name of Modigliani are all manner of ideas about the Bohemian life in Paris, the fateful poverty of the artist and his grand passions. Modigliani is the prototype of the artist who executes his work in the draughty studios of Montmartre and Montparnasse, intoxicated by alcohol, hashish, love and poetry; who, around the time of World War I, lives in the artistic heart of Paris and at the same time stands isolated on the fringes of the belle époque; who, in the capital city of the European avant-garde, surrounded by Pablo Picasso (1881–1973), Georges Braque (1882–1963), Henri Matisse (1869–1954) and Constantin Brancusi (1876–1957), never seems to waver in pursuing his own path; who experiences little or no success and is so poor that he can only just pay his bills in the legendary bars at the junction of the Montparnasse and Raspail boulevards with quickly sketched portraits of the customers; who dies – at the young age of 35 – of tuberculosis, penniless and emaciated at the end of a life which has been entirely devoted to art. To heighten the tragedy of his life even more, on the day after his death, his pregnant young fiancée, Jeannne Hébuterne, jumps from her parents' fifth-floor flat, leaving behind their small daughter as an orphan.

The few biographical details that did exist were well-suited to embellishment, thereby becoming an artist's biography par excellence. The creation of the Modigliani legend began immediately after his early death in 1920. The main perpetrators in this were those who had known him the best, the friends and colleagues in Paris, who often wrote of their impressions of this proud, stubborn Italian. Although contacts with his family in Livorno during his years in Paris from 1906 to 1920 were rather lapse, they would also play a not insubstantial role in the posthumous creation of the Modigliani myth. To begin with, there was Amedeo's mother, Eugenia Modigliani, a French

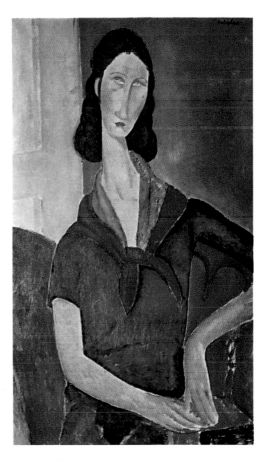

Jeanne Hébuterne, 1919
Oil on canvas, 130 x 81 cm
Ceroni 305
Private collection

ILLUSTRATION PAGE 6:
Self-portrait, 1919
Oil on canvas, 100 x 64.5 cm
Ceroni 337
São Paulo, Museu de Arte Contemporanea
da Universidade

lady who must have been remarkably emancipated for her age. She came from the upper-class Jewish Garsin family in Marseilles and believed that she was descended from the famous philosopher, Spinoza. When Eugenia married Flaminio Modigliani, the son of one of her father's Italian business partners, in 1872 and moved to Livorno, she had entered a family whose best times were just over. In the middle of the 1880s, when Amedeo, their fourth and youngest child, was born, an economic slump in Italy caused the family business in wood and coal to go bankrupt. Eugenia contributed to the family income with translations of D'Annunzio's poetry, book reviews published under a pseudonym and private lessons. Her open mind and intellectual interests undoubtedly opened the world of literature and art to Modigliani at an early age. In her diaries, his mother recounts how Modigliani's interests were fired and writes of the support that she gave him. Extracts from the diaries were published after Modigliani's death. It all began with a bad case of pleurisy, which confined the eleven-year-old Dedo – as he was affectionately known by his family – to bed for many weeks. "I have still not recovered from the terrible fright that it gave me", Eugenia records, and in her concern for her youngest child, she adds: "The child's character is still so unformed that I cannot say what I think of it. He behaves like a spoiled brat, but he does not lack intelligence. We will have to wait and see what is hidden in this doll. Perhaps an artist?"

He did indeed become an artist but, as family lore had it, a second decisive factor was needed in order for this to happen. Once again it was illness that served as a catalyst for Modigliani's career. When he was fourteen he caught typhoid fever – at the time still a fatal disease – and, according to his mother, in his delirium her son revealed his ardent desire to become an artist. He had fantasies of the masterpieces in Italy's museums and churches and when, as if by a miracle, he regained his health he was permitted to leave school and enrol at the art academy in Livorno. One may doubt the veracity of Modigliani's mother's recollections, as the artist's daughter, Jeanne Modigliani, does in her biography *Modigliani: Man and Myth*; nevertheless, this story fulfils an important function. Mapped out in Modigliani's childhood were all of the tragic highs and lows that would determine his later life. It was only by becoming an artist that he was able to recover and it was this which allowed his family to legitimise his unconventional life. The pain and hallucinations of illness ironically helped the young Modigliani recognise his goal in life, and help us to understand his later life. The "spoiled brat" becomes a dandy and "the last real Bohemian". The small, sickly boy in Livorno becomes the great, suffering artist in Paris, the painter who spares neither his strength nor his health in the creation of his work.

When Modigliani began his art studies at the age of fourteen, he was the youngest in his class. The small academy in Livorno was headed by Guglielmo Micheli (1886–1926), a student of Giovanni Fattori (1825–1908), the most famous representative of the group of Italian Impressionists known as the *Macchiaioli*. Like the French painters they modelled themselves on – Claude Monet (1840–1926), Auguste Renoir (1841–1919), Camille Pissarro (1830–1903) and Alfred Sisley (1839–1899) – the *Macchiaioli* also sought to bring scenes from nature to canvas in small blobs of colour (It. *macchia*: spot, stain).

In addition to the training he received in Guglielmo Micheli's class, Modigliani also attended a life-drawing class in Gino Romiti's studio in Livorno. In July 1900 Modigliani celebrated his sixteenth birthday. Once again, however, he fell seriously ill. To help bring about a more speedy

Pablo Picasso
Woman's Head, 1901
Oil on canvas, 46.7 x 31.5 cm
Private collection

Ernst Ludwig Kirchner
Woman with Hat, 1911
Oil on canvas, 76 x 70 cm
Cologne, Wallraf-Richartz-Museum

Head of a Young Woman, 1908
Oil on canvas, 57 x 55 cm
Ceroni 6
Villeneuve d'Ascq, Musée d'Art Moderne
Gift of Geneviève and Jean Masurel

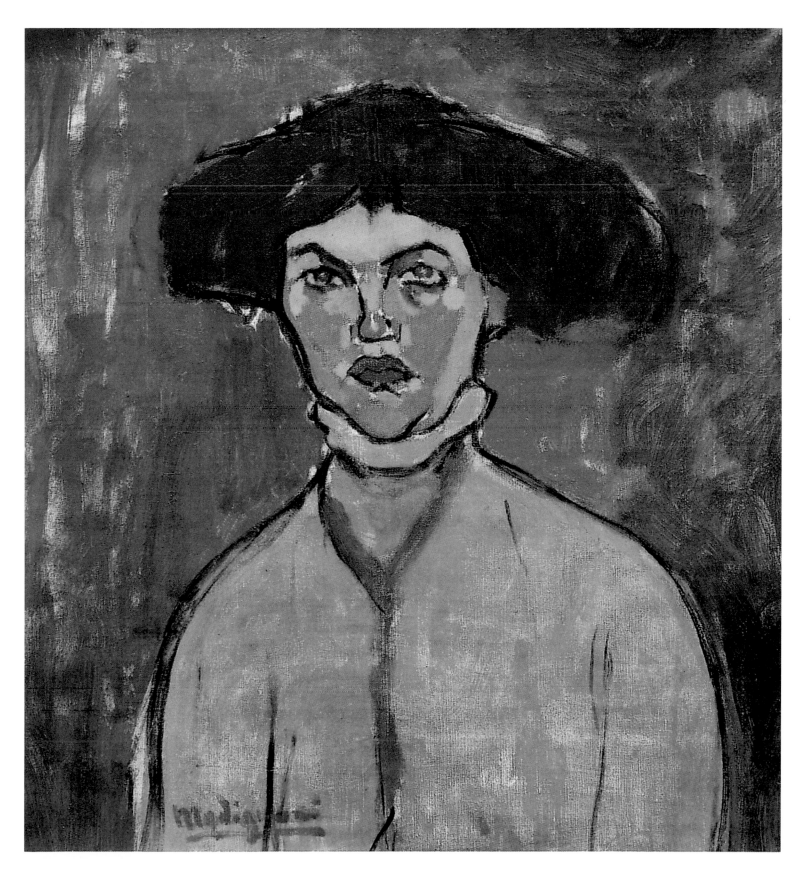

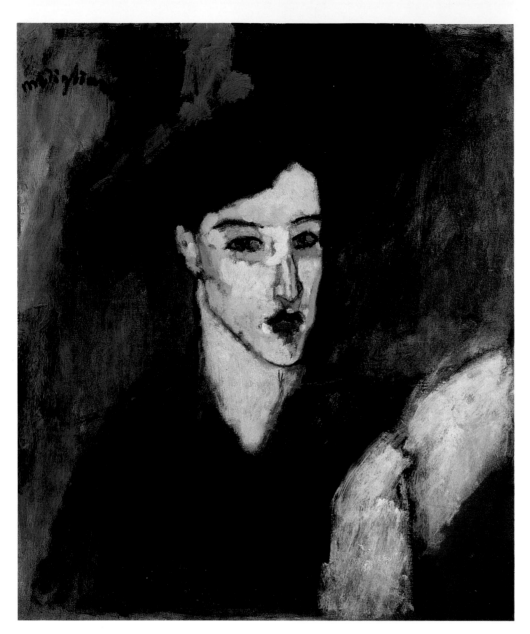

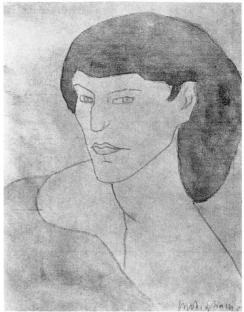

Study for: **The Jewess**, 1907/08
Chalk and watercolour, 30.5 x 23 cm
Private collection

The Jewess, c. 1908
Oil on canvas, 55 x 46 cm
Ceroni 9
Private collection

When this painting was exhibited in 1908 in
the Salon des Indépendants, the explosive
colours of Fauve painting still dominated the
scene. In contrast, Modigliani's more muted
palette was oriented towards Henri de Tou-
louse-Lautrec and Edvard Munch. Paul Cé-
zanne, who died in 1906 and whose retrospec-
tive Modigliani visited in 1907, also exerted a
lasting influence on Modigliani's painting.

recovery, he spent the winter of 1900/01 in Italy's warmer south – Naples,
Capri and Rome – accompanied by his mother. "... I am now rich in fruit-
ful ideas and I must produce my work", were the dramatic words of the
young art student to Oscar Ghiglia, his friend from the art academy in Li-
vorno, to whom he wrote a number of letters during this period of conva-
lescence and study. Modigliani's enthusiasm for Rome was boundless:
"... As I speak to you, Rome is not outside but inside me, like a terrible
jewel set upon its seven hills as upon seven imperious ideas. Rome is the
orchestration which girds me, the circumscribed arena in which I isolate
myself and concentrate my thoughts. Her feverish sweetness, her tragic
countryside, her own beauty and harmony, all these are mine, for my
thought and my work".

In the spring of 1901, Modigliani followed Ghiglia – nine years his senior –
to Florence where, after once again spending the winter in Rome, he en-
rolled at the Scuola libera di Nudo (Free School for Nude Studies). In 1903 he
went with Ghiglia to Venice, where he also took life-drawing classes. He
was quickly at home in Venice's world of cafés and artists. At the time, he
was a young man with "... a graceful countenance and gracious features.
Neither tall nor short, he was slim and dressed with simple elegance"; this is

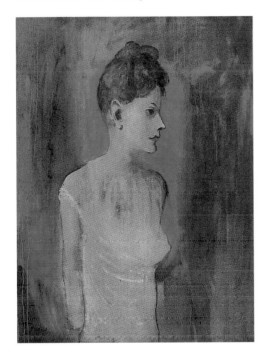

Pablo Picasso
Woman in a Chemise, 1905
Oil on canvas, 73 x 59.5 cm
London, The Tate Gallery

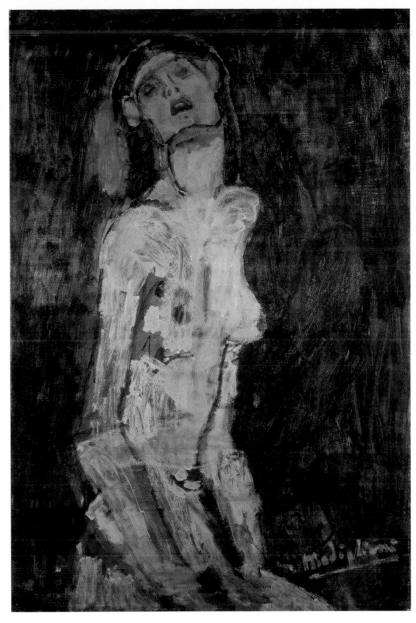

Nudo Dolente (Sorrowful Nude), 1908
Oil on canvas, 81 x 54 cm
Ceroni 8
Provenance: Richard Nathanson, London

how the painter Ardengo Soffici (1879–1964) remembers him from his visit to Venice in 1903. He found Modigliani to be a knowledgeable guide to the city. Soffici was impressed by Modigliani's "passionate interest in the painting techniques of the Sienese Trecento painters, and particularly in the Venetian, Carpaccio, whom he seemed to love the most at the time".

Modigliani appears to have spent the time before he moved to Paris more in the intensive study of Italian art history than in any further training as an artist. Nevertheless, his studies in Italy, the visits to original paintings and sculptures and thus the appreciation of an art historical tradition, the discovery of "forms full of beauty and harmony", as he put it in his letter from Rome, were some of the most important foundations for the later development of Modigliani's art. If Modigliani took in more than he produced during the time he was in Venice, his friend Oscar Ghiglia, with whom he shared a studio for a time, was all the more industrious. In 1903 Ghiglia succeeded in showing a painting – a rather traditional portrait of a woman – at the Venice Biennial. At this exhibition, contemporary painting was chiefly represented by the now universally respected French Impressionists. As far as sculpture was concerned, great homage was paid to the genius of Auguste Rodin (1840–1917). There were, however, also many works which can be

described as Symbolist, many dream-like pictures with surreal scenarios; these must have had a strong impression on Modigliani, who loved the poems of Baudelaire and Rimbaud. Unlike Impressionism, which had originated solely in France, at the end of the nineteenth century Symbolism was a pan-European movement, encompassing literature as well as the fine arts. The Symbolists shared a common goal, namely to create pictures that were contrary to visible reality. Through the irrational contents of their pictures, they wished to show that another, hidden reality could at least be conceived. The end of the nineteenth century saw Sigmund Freud in Vienna researching the effects of hallucinogenic drugs and hypnosis and preparing his seminal work on the interpretation of dreams. At the same time, artists such as the Belgian Fernand Khnopff (1858–1921) and James Ensor (1860–1949), the French Odilon Redon (1840–1916) and Gustave Moreau (1826–1898), the Norwegian Edvard Munch (1863–1944) and the Austrian Alfred Kubin (1877–1959) were attempting to develop pictorial symbols for spiritual and mystic contents, for psychological moods and for suggestive apparitions in dreams.

There are too few surviving paintings from Modigliani's student years to allow one to ascertain a direct influence of Symbolist painting. Later, however, during the first years in Paris, a few paintings adopted the motifs of *fin de siècle* painting. These include the half-figure *Sorrowful Nude* of 1908 (ill. p. 11). If one compares Modigliani's gaunt, female figure to the figures of the Belgian Art Nouveau painter, George Minne (1886–1941), or with Edvard Munch's lithograph *Madonna*, the similarity in the perception of the body becomes all too evident. In the motif of the head bent back and the mouth slightly opened as if in pain, suffering and ecstasy, sensuality and pain are rendered as being close to each other. These figures present themselves to us removed from reality. They are locked in silence and introspection. All expression of the individual person is completely hidden behind a mask-like countenance.

The eyes – "mirrors of the soul" – play an unusually important role in the work of the Symbolist painters. Whether closed as in sleep, open or blind, they are always a visionary organ, one which can be directed both outwards and inwards. This is significant for Modigliani's later development as a painter, insofar as the eyes of his sitters also take on the visionary role they had already played for the Symbolists. Moreover, the silent introversion and the depersonalised visage, in which all subjectivity has been relinquished for an expression beyond all individualism, characterise Modigliani's later portraits and document his lasting intellectual connection to Symbolist painting.

The Venice Biennial of 1903 certainly offered art which was new and exciting, but did not display the latest trends. After spending two years in Venice, Modigliani took the only step possible for a young, ambitious artist of this time: he went to Paris.

Paris in 1906: France's capital had 2.73 million inhabitants, and 978 kilometres of streets; the boulevards designed by Haussmann were the pride of the Parisians. 9,622 arc lamps and almost half a million electric light bulbs illuminated the "city of lights", whose emblem had become the Eiffel Tower built for the World Exposition in 1889. "In the richness and diversity of its art treasures, Paris stands alone" was how an encyclopedia of 1906 put it. Under the entry "fortification" it reads: "While Paris in 1840 was an open city, it is now the world's largest military fortification".

Modigliani arrived in Paris eight years before the outbreak of World War I. These years were amongst the most eventful in the history of Euro-

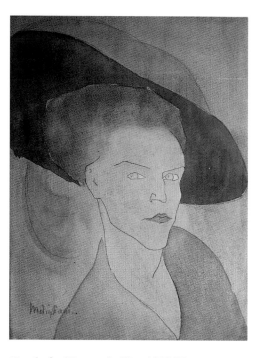

Head of a Woman in Hat, 1907/08
Watercolour, 35.2 x 27 cm
Boston, MA, William Young & Co.

ILLUSTRATION PAGE 13:
Female Nude with Hat, 1907/08
Oil on canvas, 81 x 54 cm
Ceroni 7a
Provenance: Richard Nathanson, London

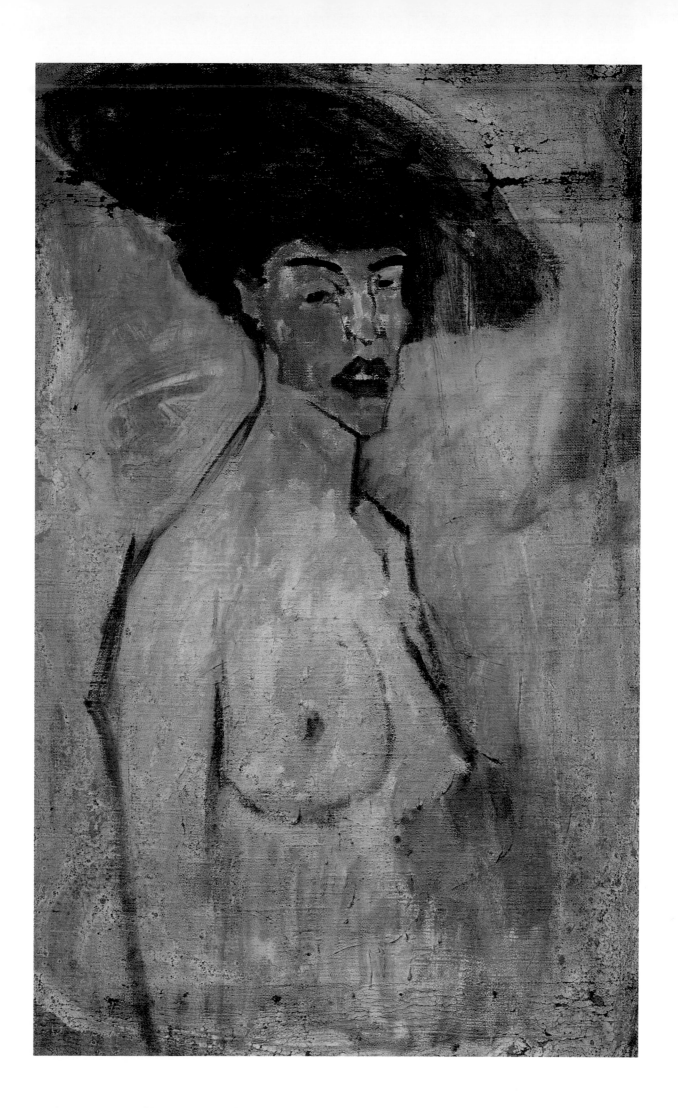

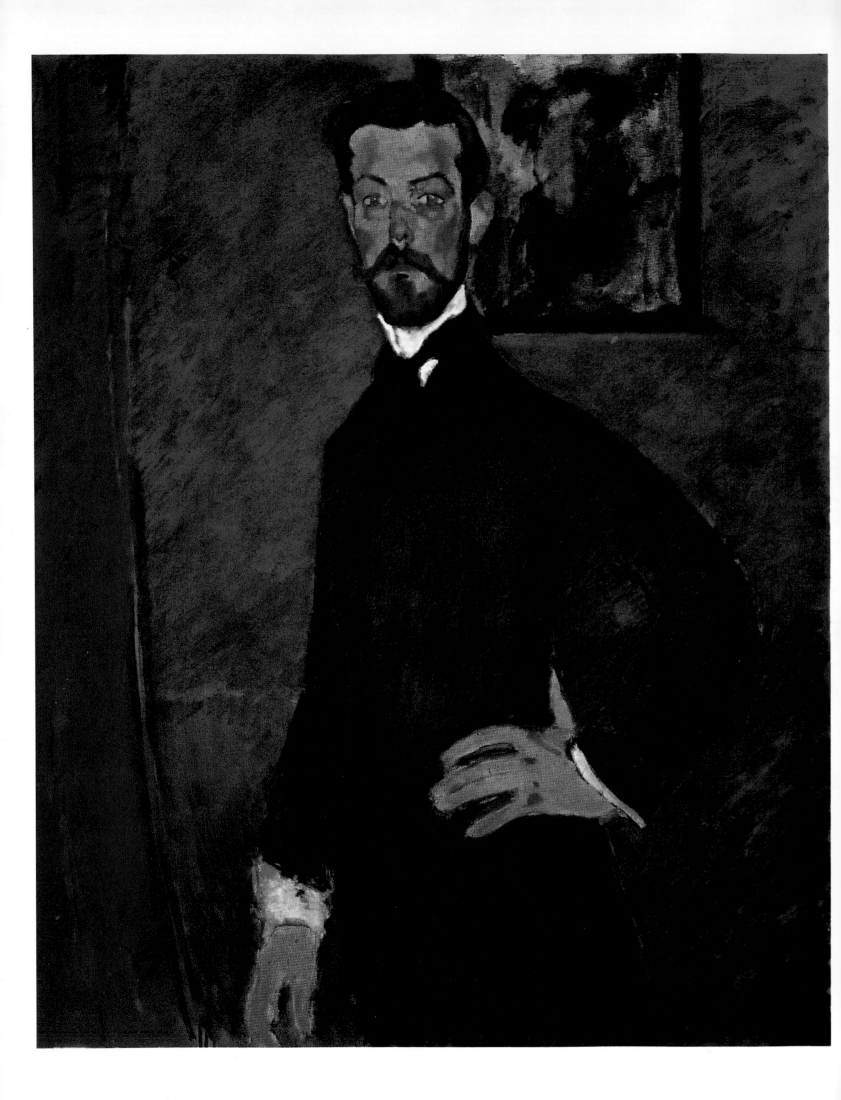

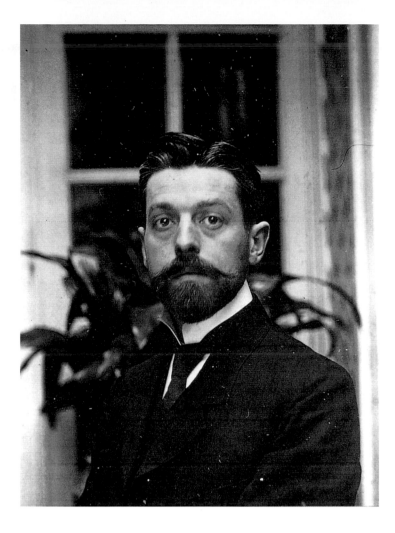

Study for: *Portrait of Paul Alexandre*, 1909
Chalk on paper, 27 x 19.8 cm
Private collection

TOP LEFT:
Paul Alexandre, 1909

pean art. It was during these years that the seeds were sown of further devel-
opments in the twentieth century – a process that was violently interrupted
by the first international catastrophe of the twentieth century. In the Paris of
1906, however, there were no signs of an approaching war for an Italian
artist looking to the future. Other things – which, at the time, could not be
read about in an encyclopedia – were of far greater importance to him. He
would have been interested in the fact that Paris was the unqualified capital
of European avant-garde painting; that many progressive art dealers in the
city were on the lookout for young talent; that only in the preceding year a
violently colourful and wild style of painting had conquered the Salon
d'Automne. This was a style linked to the unknown names of Henri Matisse,
André Derain (1880–1954) and Maurice de Vlaminck (1876–1958), upon
whom the critics had bestowed the sarcastic name "Les Fauves" ("wild
beasts"). Modigliani would also have been interested in the fact that the art
scene was still centred around Montmartre – indeed, that it had actually just
been renewed and rejuvenated by figures such as Picasso, Juan Gris (1887–
1927) and other residents of the legendary Bateau Lavoir – and that this
area still had the reputation for good times in the cafés, theatres and dance
halls which had been immortalized by Henri de Toulouse-Lautrec (1864–
1901). Paris in 1906: the start of the second phase of the modern move-
ment. With the death of Paul Cézanne (1839–1906) on October 22, 1906,
the last – after Vincent van Gogh (1853–1890) and Paul Gauguin (1848–
1903) – of the three Post-Impressionist "founding fathers of the modern
movement" had died. In the same year, the French state bought Edouard
Manet's (1832–1883) *Déjeuner sur l'herbe*, a work that had been con-
sidered outrageously modern in 1863. Its depiction of a naked woman at a

ILLUSTRATION PAGE 14:
*Portrait of Paul Alexandre against a Green
Background,* 1909
Oil on canvas, 100 x 81 cm
Ceroni 14
Private collection

15

picnic in the forest with properly dressed gentlemen had caused an enormous scandal in the French art world.

Being the good, bourgeois boy that he was, Modigliani first stayed in a comfortable hotel on the right bank of the Seine upon his arrival in Paris. Soon, however, he moved up to Montmartre where, according to the art critic Adolphe Basler, his quick wit and good looks "quickly made him popular". One of Modigliani's first friendships in Paris was formed with the German artist Ludwig Meidner (1844–1966), who had come to Paris for one year to study at the Académie Julian. Meidner later recalled Modigliani's early days in Paris and, like Basler, he emphasised the impression that Modigliani made on those around him. "In the first decade of our century, one still had a taste for the Bohemian life that had developed in the nineteenth century; in Paris – on Montmartre and Montparnasse – the last representatives of this world were the sophisticated and spoiled sons of the old bourgeoisie. Our Modigliani – or 'Modi' as he was called – was a characteristic and, at the same time, highly talented representative of Bohemian Montmartre; he was probably even its last true Bohemian." Meidner also records, however, that he was impressed by the open-mindedness, *esprit* and commitment shown by Modi (whose nickname was undoubtedly an illusion to the *peintre maudit*, or "accursed painter"). And here, too, the Italian origins play an important role. "Never before had I heard a painter speak of beauty with such fire. He showed me photographs of works by early Florentine masters whose names I did not yet know."

In 1907, Modigliani probably participated in the Salon d'Automne (Autumn Salon) in the Grand Palais. Founded a few years earlier, it was reserved for the avant-garde. This exhibition forum, where no jury presided, was still dominated by the Fauvists, whose expressive application of colour represented a further step towards the autonomy of the pictorial plane and away from the illusionistic reproduction of objects. Van Gogh had already

Study for: *The Amazon*, 1909
Chalk, 29.5 x 21.5 cm
New York, Mr and Mrs Alexander Lewyt
Collection

TOP LEFT:
Henri de Toulouse-Lautrec
The Clownesse Cha-U-Kao at the Moulin Rouge, 1895
Oil on canvas, 75 x 55 cm
Winterthur, Oscar Reinhart Collection

ILLUSTRATION PAGE 17:
Woman in Yellow Jacket (The Amazon), 1909
Oil on canvas, 92 x 65 cm
Ceroni 21
Private collection

Through his friendship with Dr Paul Alexandre, Modigliani received his first portrait commission. When the portrait was almost finished, Modigliani painted over the Baroness' red riding-jacket in yellow. She thereupon refused the portrait and Paul Alexandre bought it.

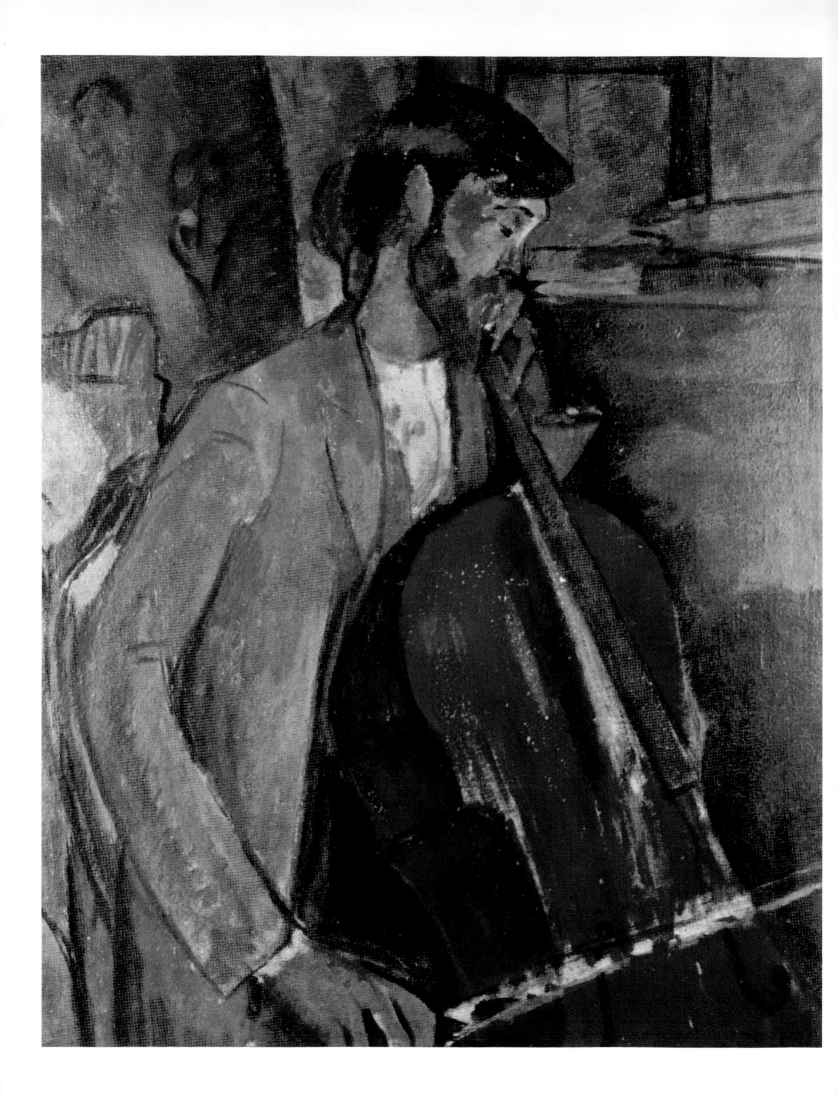

shown that pure, unmixed colours could serve to express moods. Gauguin, whose contribution to the development of the modern movement lay in his radical concentration on the pictorial surface, had said: "Before one even knows what the picture represents, one is immediately seized by the magical chords of its colours". Even more radical was Matisse's observation made a short time afterwards: "Seek the strongest colour effect possible – the content is of no importance".

Modigliani's tentative searching in the midst of the different avant-garde movements is apparent in his portrait *The Jewess* (ill. p. 10). The statuesque, severe-looking figure betrays the influence of the linear style of Toulouse-Lautrec. There are also echoes of the emaciated figures of Picasso's Blue Period. Despite the loose brushwork, *The Jewess* is an extremely measured painting whose main aim lies not in achieving an autonomy in the use of colours and planes, but rather in conveying a mood. Scepticism, restraint and the sitter's challenging gaze all demonstrate the painter's interest in the psychology of his subject. There are, however, also parts of this picture which are strongly defined by the purely painterly treatment of the surface, such as the field of colour in the lower right-hand corner to which no concrete object can be assigned. Modigliani must have taken notice of Maurice Denis' (1870–1943) classic definition, namely that "a picture, before being a battle charger, a nude woman or a story, is essentially a flat surface covered with colours arranged in a certain pattern".

Nevertheless, Modigliani's pictures differed from those which reaped success – albeit often too rashly – in the turbulent pre-war years. When *The Jewess* was exhibited in the Salon des Indépendants in 1908 the hectic wheel of art "-isms" had turned once again. Cubism came on the scene, shattering conventional notions of space and perspective and thereby ways of looking at paintings. Pablo Picasso – whose *Les Demoiselles d'Avignon* (ill. p. 26) of 1907 was the introduction to Cubist painting – and Georges Braque were the new heroes of the art world, and Modigliani's work was barely noticed. The most influential critic and poet of the age, Guillaume Apollinaire (1880–1918), did mention Modigliani's name in his discussion of the Salon, although he only "looked briefly" at his exhibited works. Nevertheless, Modigliani was not completely ignored. One day in the spring of 1907, the painter Henri Doucet brought him along to the house in the Rue de Delta that a certain Dr Paul Alexandre had rented for young artists. Alexandre, a young doctor who had just finished his studies, was fascinated by Modigliani's paintings and began to support the Italian as well as he could. He bought his drawings and paintings and arranged for portrait commissions. This friendship would produce some of the best portraits painted by Modigliani during his time on Montmartre. The sketches and a photograph (ill. p. 14) that preceded the large *Portrait of Paul Alexandre against a Green Background* (ill. p. 15) make clear that Modigliani had his subject model for him in the traditional way. On the wall behind Dr Alexandre is the painting of (or a preliminary study for) *The Jewess*. This was his way of identifying Dr Alexandre as an art collector. It is an absolutely classic portrayal; the subject is presented in a distinguished and self-confident pose, a member of the upperclass and an intelligent man, who has let himself be immortalised in an imposing portrait. The lighter shading of the forehead and the emphasis of the eyes can undoubtedly be traced back to the photograph of the doctor taken at almost exactly the same time. In these early portraits, Modigliani's aim still lay in capturing the psyche of his sitter. It was an aim which he shared with Edvard Munch, whose paintings had caused a great stir in the Salon d'Automne of 1908.

Portrait of Frank Burty Haviland, 1914
Oil on cardboard, 72.5 x 59.5 cm
Ceroni 44
Milan, Gianni Mattioli Collection

ILLUSTRATION PAGE 18:
Study for ***The Cellist***, recto, 1909
Oil on canvas, 73 x 60 cm
Ceroni 22a
Private collection

Sketch for a *Portrait of Brancusi,* on the back
of the study for *The Cellist,* 1909
Oil on canvas, 73 x 60 cm
Ceroni 22b
Private collection

ILLUSTRATION PAGE 21:
Man with Beard, c. 1918
Ink on paper
Philadelphia, PA, Mrs Sydney G. Biddle
Collection

With his talent for the concentrated portrayal of the characteristic traits of
his sitters, and with his feeling for elegant forms and colours, Modigliani
could easily have become one of the most sought-after portraitists of Pari-
sian high society. Paul Alexandre, who came from one of the city's upper-
class families, was certainly in a position to provide Modigliani – by now
living in a very simple studio on Montmartre – with access to these social
circles. In 1909, Modigliani painted the impressive portrait of the Baroness
Marguerite de Hasse de Villers in riding-habit, known today as *The Amazon*
(ill. p. 17). Preparatory drawings for the painting (cf. ill. p. 16) allow one to
see how Modigliani slowly encircled his subject, playing through various
possibilities of expression before finally arriving at a subtle understanding
of the portrayed person. Arrogance, self-confidence, pride and flirtatious-
ness, as well as a great measure of reserve, are all evident in the Baroness'
gaze. When completed, she harshly rejected this portrait and refused to pay
for it.

Modigliani did not become the portraitist of the belle époque after all. The
path that he followed as an artist led him ever further away from his origins.
The artist Curt Stoermer, who made Modigliani's acquaintance in 1909, has

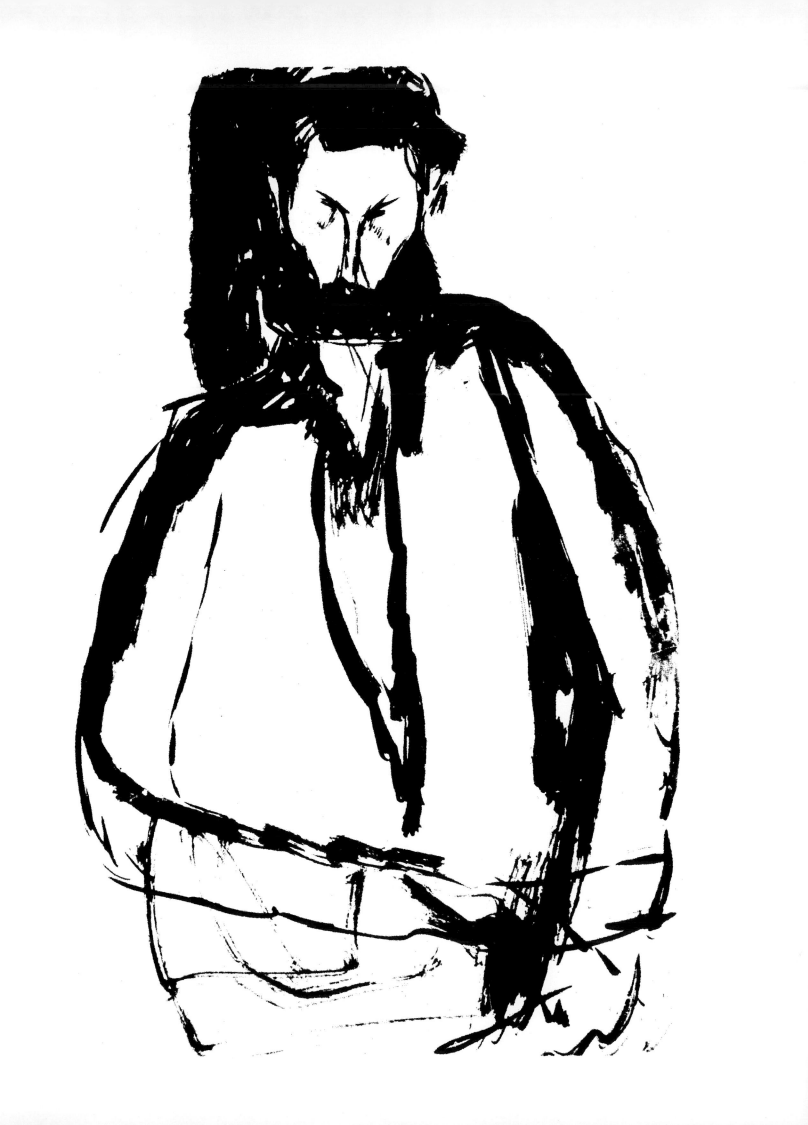

given a shrewd description of the change in Modigliani's artistic views. He visited the artist in his studio and saw the completed painting *The Cellist* (cf. ill. p. 18, study for *The Cellist*) – which according to Stoemer "already enjoyed a secret celebrity". Stoermer admired the painting's "extremely subtle technique", which, through an artistic differentiation of colours, allowed the musician to merge into his instrument and showed him in a curious state of reverie. "Later", Stoermer continued, "I saw in [Modigliani's] subsequent works that the strongly emotional style of *The Cellist* represented a stage in his development that he soon left behind him. He hated feelings. What does a painter have to do with moods? He blotted out content, his painting became objective, his drawings were condensed to precise contours which flowed unconsciously from his extremely nervous hands."

Modigliani's later paintings really did exhibit this leaning towards the general, one could even say towards the anonymous, achieved by both a stringent reduction of the narrative and a virtuoso stylisation of the represented subject. Modigliani developed his own ideal of beauty to which he subordinated the appearance of his portrait models. This painterly ideal is quite separate from questions of psychology and character; it is a rigorous quest for a personal style, for "harmonious and beautiful forms". If, in the first years of this quest, Modigliani still oriented himself towards the work of figures such as Toulouse-Lautrec, Munch and Cézanne, he later seems to have needed a detour in order to attain the stylistic independence which would impart such unity to his later paintings and which makes them gen-

BOTTOM RIGHT:
Nude Bending to Side, 1909
Chalk on paper, 43 x 26 cm
Private collection

The Beggar of Livorno, 1909
Oil on canvas, 65 x 54 cm
Ceroni 24
Private collection

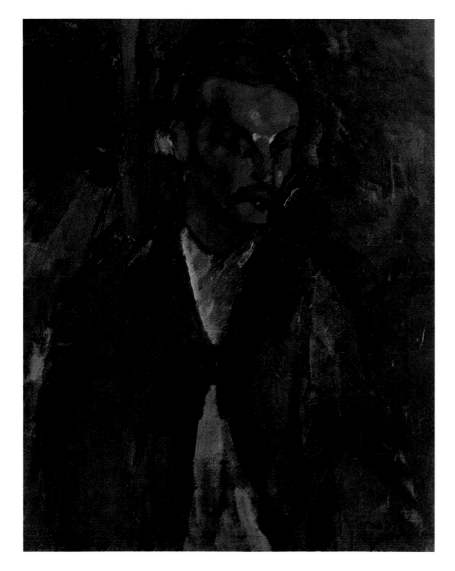

uine "Modiglianis". For a time, this was to lead Modigliani away from painting and to sculpture. Constantin Brancusi, a Romanian sculptor living in Paris, was producing powerful, idol-like sculptures of elegantly proportioned beauty; he was to prove instrumental in Modigliani's artistic development at this time. The unfinished portrait of Brancusi on the back of Modigliani's study for *The Cellist* (ill. p. 20) allows the acquaintance of the two artists to be dated from the year 1909, considered to be the year in which Modigliani turned to sculpture.

BOTTOM LEFT:
Nude on Divan, c. 1909
Charcoal on paper, 43 x 26 cm
Private collection

Woman's Head, 1910
Oil on canvas, 55 x 38 cm
Ceroni 30
Private collection

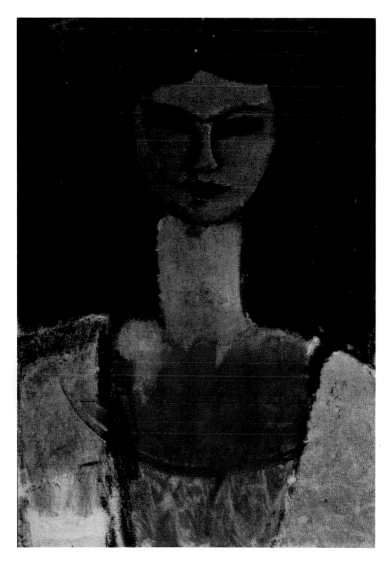

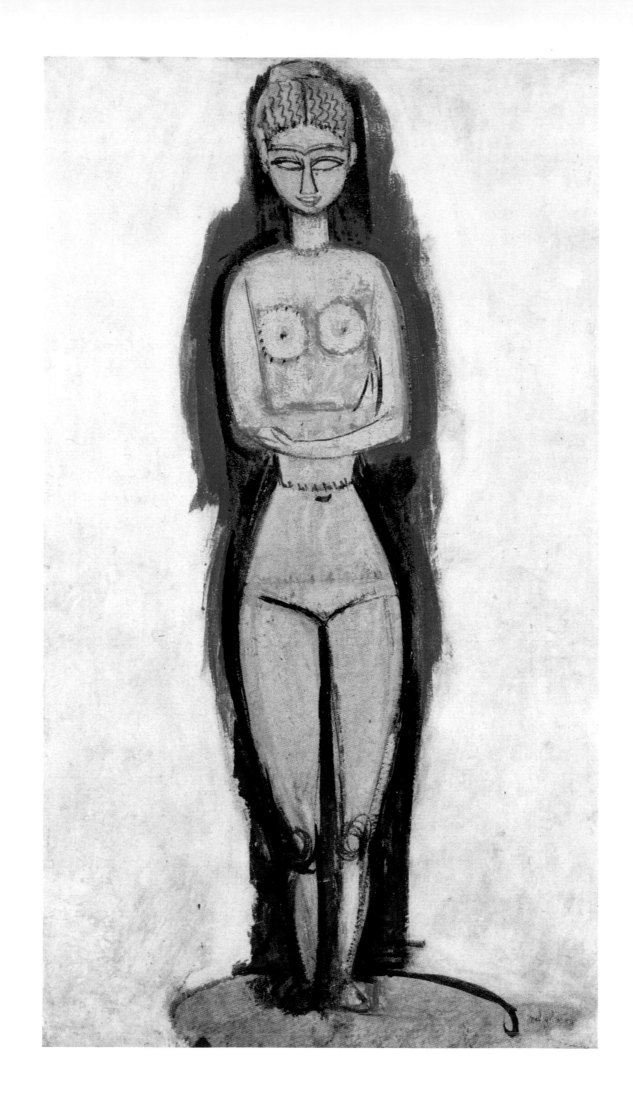

Columns of Tenderness

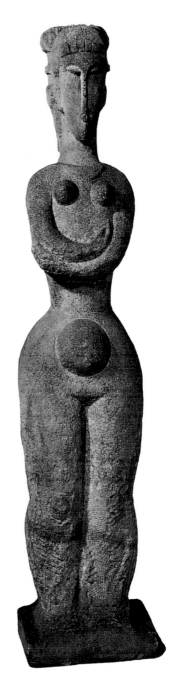

One can only speculate on the reasons that led Modigliani to turn from painting to sculpture in 1909. It is possible that Italy's heritage from Antiquity had made such an impression upon him even as a youth that he had even then felt drawn towards sculpture, or so claims Ortiz de Zarate, a friend who had known Modigliani since their student days in Venice. It is also possible that up to this point, Modigliani had only lacked the opportunity to pursue stone sculpture and that having moved into a studio with a courtyard he was able to devote himself to the genre. Another theory is that the stagnating success of Modigliani's painting led him to experiment in another area. Even his contemporaries do not offer a satisfactory answer to the reason for Modigliani's change of course. "He had a tremendous urge to make sculptures" is the rather melodramatic explanation of the artist Curt Stoermer. He is one of the few who described the manner in which Modigliani proceeded. "Having ordered a large piece of sandstone to be placed in his studio, he cut directly into the stone. Just as there were times when he loved idleness and indulged in it with the greatest sophistication, there were also times when he plunged himself deep into work. The morning's first rays of light already saw him with the chisel in his hand. He cut all his sculptures directly into stone, never touching clay or plaster. He felt called to be a sculptor. At certain periods the urge would come upon him. Then he would thrust all painting tools aside and snatch up his hammer." More likely than this heroic, Michelangelo-like explanation is that at this time, Modigliani – like other artists such as Matisse, Picasso and Derain, who were also sculpting – was deeply influenced by two things which led him to put his painting-tools to one side: one was African sculpture, whose beauty was discovered in the years prior to World War I, and the other were Brancusi's sculptures, exhibited at the same time as Modigliani's works at the Salon d'Automne in 1907 and at the Salon des Indépendants in 1908.

Brancusi had been living in Paris since 1904 and had just moved to a studio in the Rue de Montparnasse when he and Modigliani met in 1909. It is possible that Modigliani left Montmartre in this year and moved into a studio on Montparnasse in order to be closer to Brancusi. Perhaps, however, his move was just part of a trend amongst the artists in Paris. Many were fleeing the idyll of Montmartre which had become inundated with tourists. All one can say for certain is that for a time Modigliani devoted himself to sculpture in the courtyard of his studio at the end of the small cul-de-sac, Cité Falguière. This was around 1910, a time when he produced strikingly few paintings and his mother's letters were addressed to "Modigliani, scultore". Approximately twenty-five stone sculptures and a wood carving still exist. The art criticism on this period is of differing opinions as to stylistic development and the dating of the sculptures. The one point that is agreed

Caryatid, 1912/13
Limestone, 162.8 x 32.2 x 29.6 cm
Canberra, Australian National Gallery

ILLUSTRATION PAGE 24:
Standing Nude, 1911/12
Oil on cardboard, on panel, 82.8 x 47.9 cm
Ceroni 34
Nagoya, The Nagoya City Art Museum

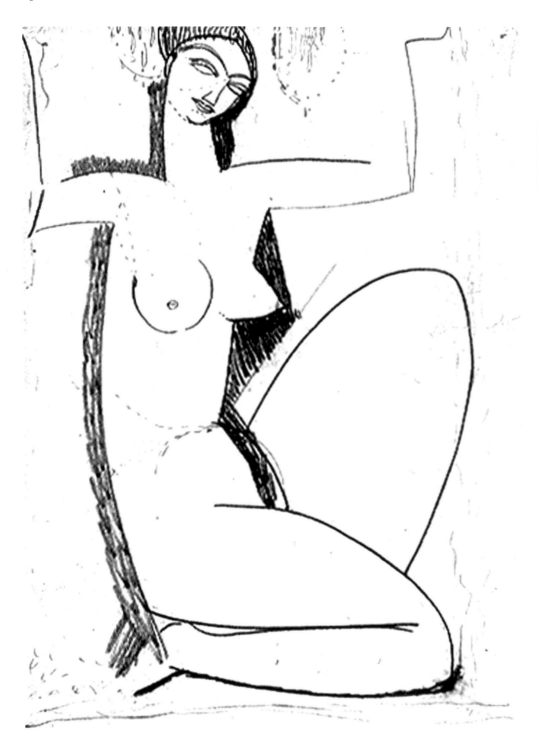

Caryatid, c. 1912/13
Pencil on paper, 39.7 x 25.7 cm
Dijon, Musée des Beaux-Arts
Granville Donation

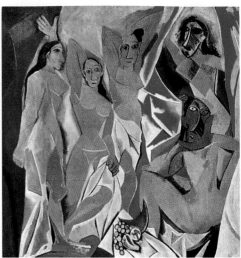

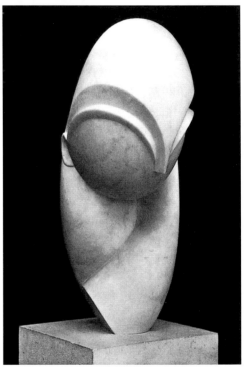

Pablo Picasso
Les Demoiselles d'Avignon, 1907
Oil on canvas, 243.9 x 233.7 cm
New York, The Museum of Modern Art
Acquired through the Lillie P. Bliss Bequest

Constantin Brancusi
Mademoiselle Pogany, 1913
Marble, height 44 cm
Paris, Musée National d'Art Moderne
Centre Georges Pompidou

ILLUSTRATION PAGE 27:
Rose Caryatid (Audace), c. 1914
Gouache and chalk on paper, 60 x 45.5 cm
West Palm Beach, FL, Norton Gallery of Art

upon, however, is that Modigliani's sculpture phase lasted from 1909 to 1914.

The distinguishing feature of the sculpture is that it extends in three dimensions and thus always maintains a relationship to the human body. In Antiquity and in the Renaissance it was man himself who was the predominant subject of sculpture. Unlike other plastic art forms produced by the addition of material, a sculpture is produced by taking something away from the existing material, be it a block of stone or of wood. This procedure had led Michelangelo (1475–1564) to the Neoplatonic view that every stone worked by a sculptor already carried within it the resulting image; the sculptor merely liberated the sculpture from the superfluous stone. The fact that the sculptor is responsible for every single blow of the hammer and cannot later undertake corrections was for Michelangelo and for the generations of sculptors after him a question of artistic judgement, to be seen ultimately as

Caryatid, 1914
Limestone, 92.1 x 41.6 x 42.9 cm
New York, Museum of Modern Art
Mrs Simon Guggenheim Fund

Caryatids were used in the architecture of
classical antiquity to support entablatures or
other similar members. Modigliani used this
motif in roughly sixty drawings and several
paintings. The drawing on page 26 shows
candles arranged in a wreath around the head
of the caryatid. Contemporaries report that
this is how Modigliani illuminated his sculp-
tures.

Stone Head, 1911/12
Limestone, 71.1 x 16.5 x 23.5 cm
Philadelphia, PA, Philadelphia Museum of Art
Donated by Mrs Maurice Speiser in memory
of her husband

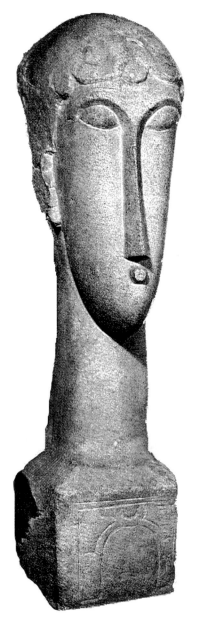

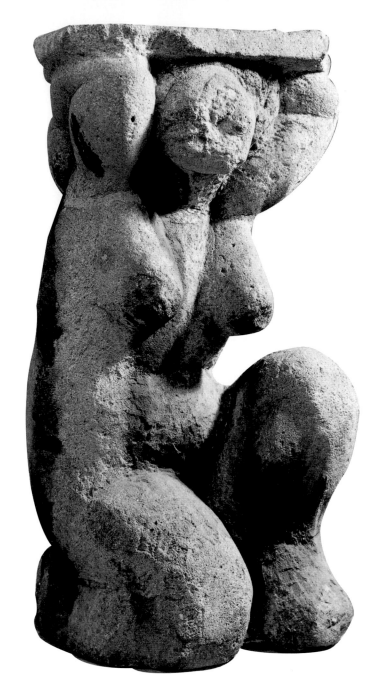

a God-like power. When Modigliani, who, if one recalls, did not have any
training as a sculptor, opted for the difficult work with stone – rejecting
work in plaster, modelling clay and potter's clay as carried out, for example,
by Rodin – he was intuitively seeking the connection with a noble tradition.
"I will make everything in marble", he wrote somewhat pompously to his
friend Paul Alexandre while he was in Italy for three months in the spring of
1913. Rather more modestly he added: "Fulfilment is approaching. But if I
don't work for another two weeks, it will miss the mark."

According to the art historian Gerhard Kolberg, Modigliani's sculptures
fluctuate "between a high ideal and sculptural goal and 'primitive' to archaic
execution". It is, nonetheless, astonishing that from the very beginning this
novice was able to impart a stylistic unity to his sculptures. Each head can
immediately be recognized as chiselled by Modigliani. Seen from this as-
pect, it is easy to understand Stoermer's opinion that Modigliani felt it was
his calling to be a sculptor.

Modigliani's phase as a sculptor began with his move to Montparnasse, a
then new suburb of Paris. On the Boulevard Raspail and the Boulevard

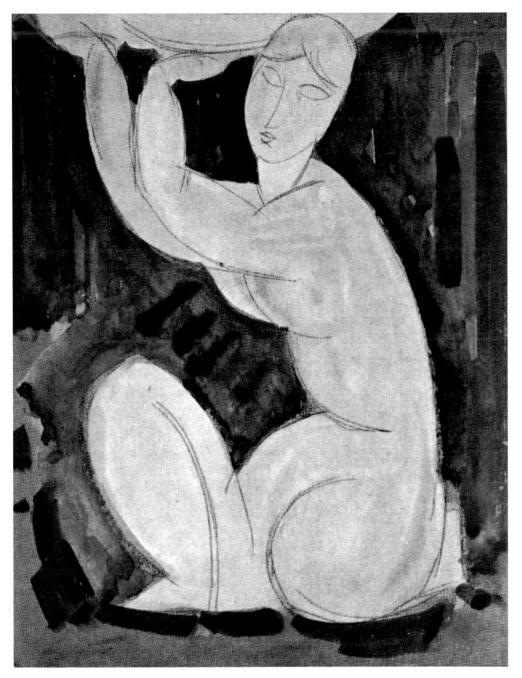

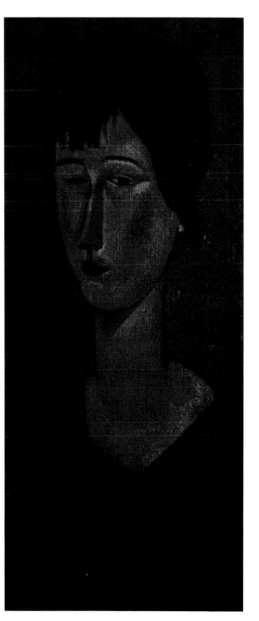

Caryatid, 1913
Pencil and watercolour, 33.5 x 27.3 cm
Private collection

Marcelle, 1917
Oil on canvas
Private collection

Montparnasse, magnificent new houses were under construction. At the same time, work was still being carried out on the underground Métro system. It has been said that Modigliani took the big blocks of stone that he used for his sculptures from the surrounding construction sites and – if one believes the story – that his wooden heads were carved from the railway sleepers intended for the Métro. Modigliani's sculptural pieces have similar dimensions and are highly rectangular, stele-like objects with almost no forms that extend into space.

At an exhibition in 1911, Modigliani showed several of these heads as a "decorative ensemble". The uniformity of the different sculptures can be explained by the fact that they were conceived to be presented together. It is not the individual work which is of importance but rather the overall view of the stone heads. In order to heighten the total effect of the ensemble, Modigliani had his sculptures illuminated in a special way. A number of contemporaries relate that he had his works lit by candlelight. With this ceremonial setting, Modigliani wanted his sculptures to make a mysterious, quasi-religious impression. If one imagines these stones, presented in the half-dark

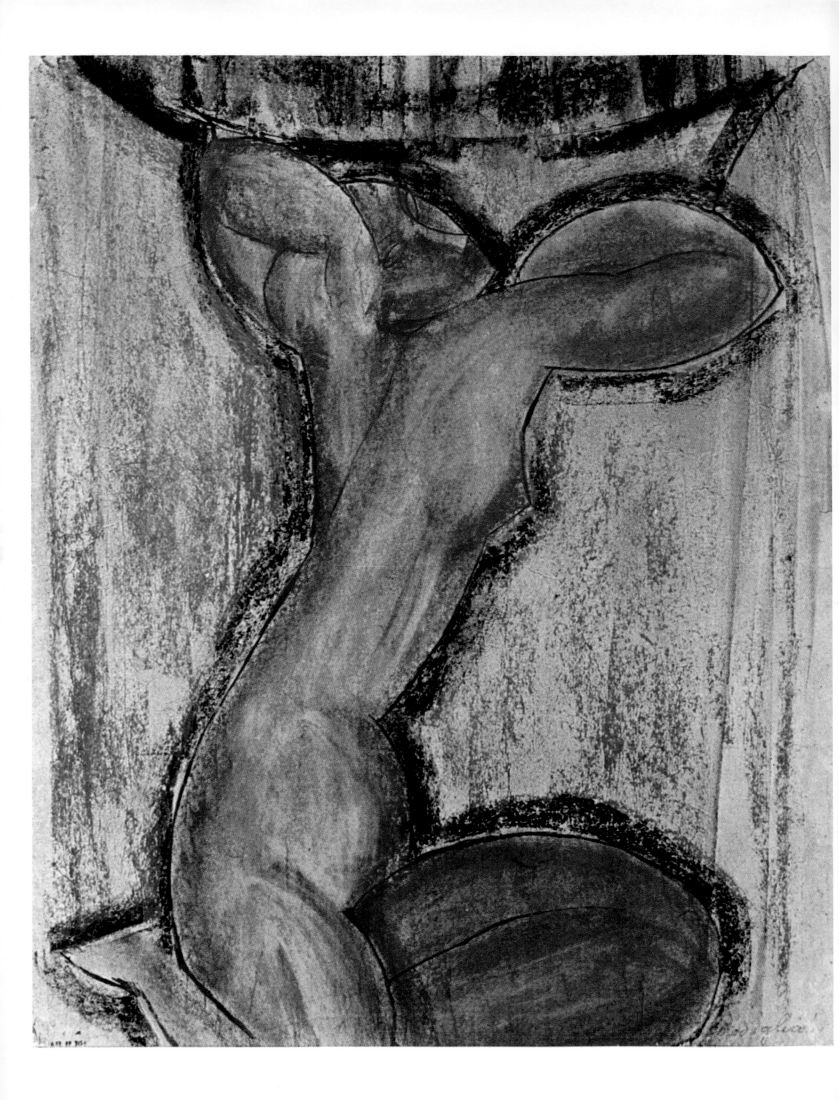

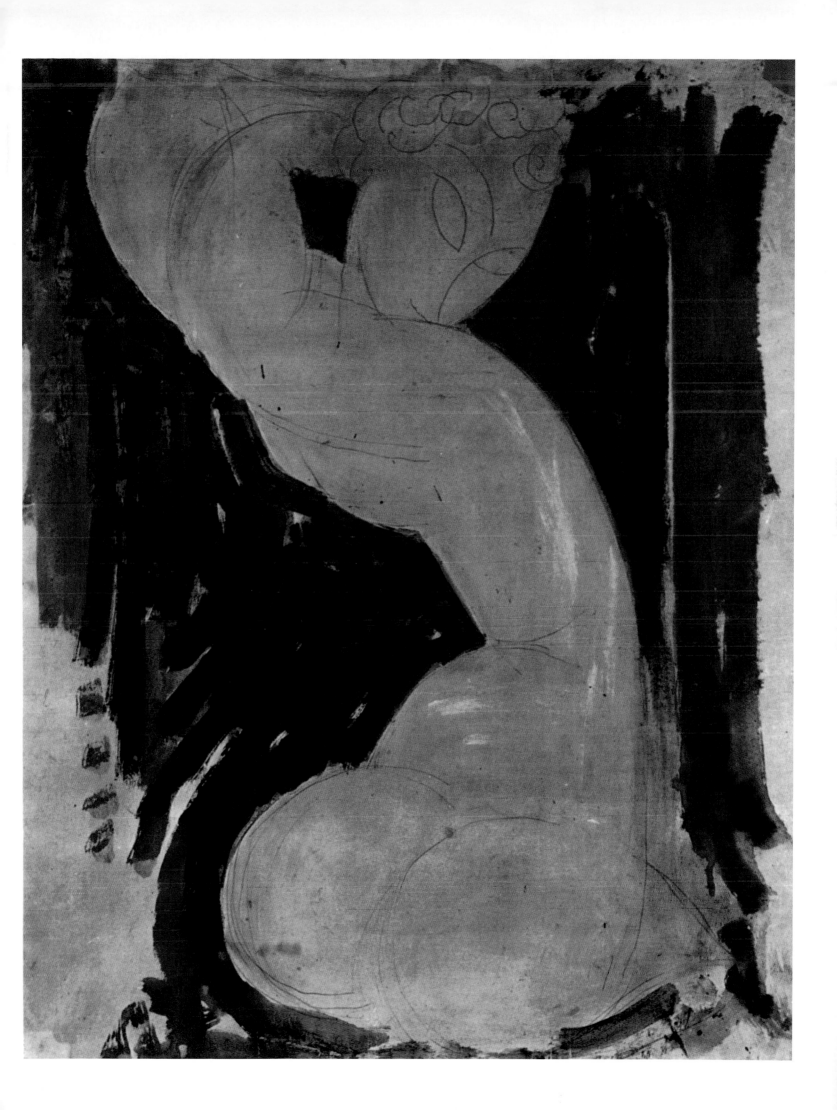

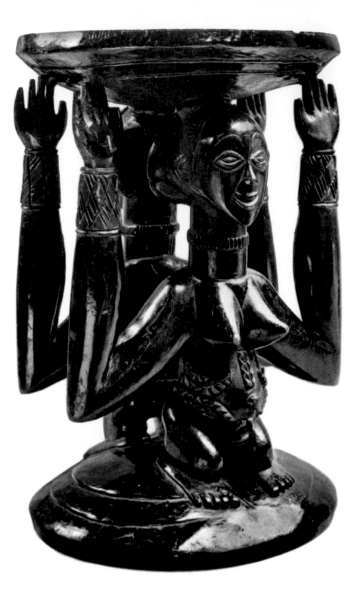

Baluba, Republic of the Congo
Wood, height 40 cm
Turvuren, Musée Royal de l'Afrique Centrale

TOP RIGHT:
Caryatid Head, c. 1909
Chalk on paper, 32 x 27 cm
Private collection

ILLUSTRATION PAGE 30:
Caryatid, 1913/14
Pencil, pastel and watercolour on paper,
53 x 43.8 cm
Paris, Musée d'Art Moderne de la
Ville de Paris

ILLUSTRATION PAGE 31:
Caryatid, 1913/14,
Pencil and tempera on paper, 90 x 70 cm
Private collection

with the candlelight flickering, one immediately thinks of ritual vows, of
heathen rites and myths of the past. According to reports, Modigliani
referred to his sculptures as "columns of tenderness" which he wanted to see
placed in an imaginary "temple of beauty". There is something poetic in
Modigliani's approach to sculpture. The stone objects become akin to magic
idols. Their archaic characteristics – the marked stylisation of the heads, the
elongated necks, the arrow-like noses, and the eyes that are only depicted as
contours – are deliberate references to the "primitive" sculptures which were
at that time eliciting great attention from avant-garde art circles in Paris. Yet
there is only a rough similarity between Modigliani's sculptures and the so-
called Negro sculptures or cult objects of heathen antiquity, such as the
sculptures of the Cyclades. There is no evidence of a concrete, formal adop-
tion of these styles in any of Modigliani's sculptures. Their elegant reduc-
tions are a paraphrase of Primitivism. There can be no doubt, however, that
Modigliani's sculptures were inspired by non- or early European forerun-
ners. At the very least they resemble them in the generalised simplicity of
their expression.

In formal terms, there is a distinct tendency towards the statuary and the
tectonic in Modigliani's sculptures. Apart from the stone heads of undefined
beings, this finds expression in a second group of works to which Modi-
gliani devoted himself as a sculptor, but even more as a draughtsman and
painter. Modigliani's interest in the subject of caryatids shows only too

clearly that he had decided to look back to Greek and Roman Antiquity, where caryatids were architectural supports taking human form. They bore the weight of the structures above them, either entire storeys or entablatures. Modigliani's three-dimensional *Caryatid*, today in New York's Museum of Modern Art (1914, ill. p. 28), recalls the function of the caryatids of Antiquity only in its pose. Kneeling on one leg, her other leg bent towards her body, the powerfully-built female figure has raised both arms above her head in order to support the weight which has been suggested by Modigliani in a horizontal slab. Unlike Modigliani's other heads, mostly polished to smoothness, the surface on this load-bearer has been left rough, so that the work of the hammer and chisel can be clearly discerned. In the contrast between the hewn form and the rough stone, one is reminded of Michelangelo's *Slaves*, and especially of his *Dying Slaves* in the Louvre, in which the struggle with death has been presented in the same restrainedly tortured and yet powerful gestures which also characterise Modigliani's sculpture.

The original architectonic function of a caryatid as a load-bearing support is abandoned by Modigliani in favour of the expression of an attitude or pose. In his hands, the caryatid becomes the quintessential representation of a person carrying a burden. Modigliani was not especially interested in the resolution of genuine problems for the sculptor, such as body volumes and spatial effect; his focus lay instead upon the symbolic content of the figure.

It is a well-known fact that archaic sculpture had an immense influence

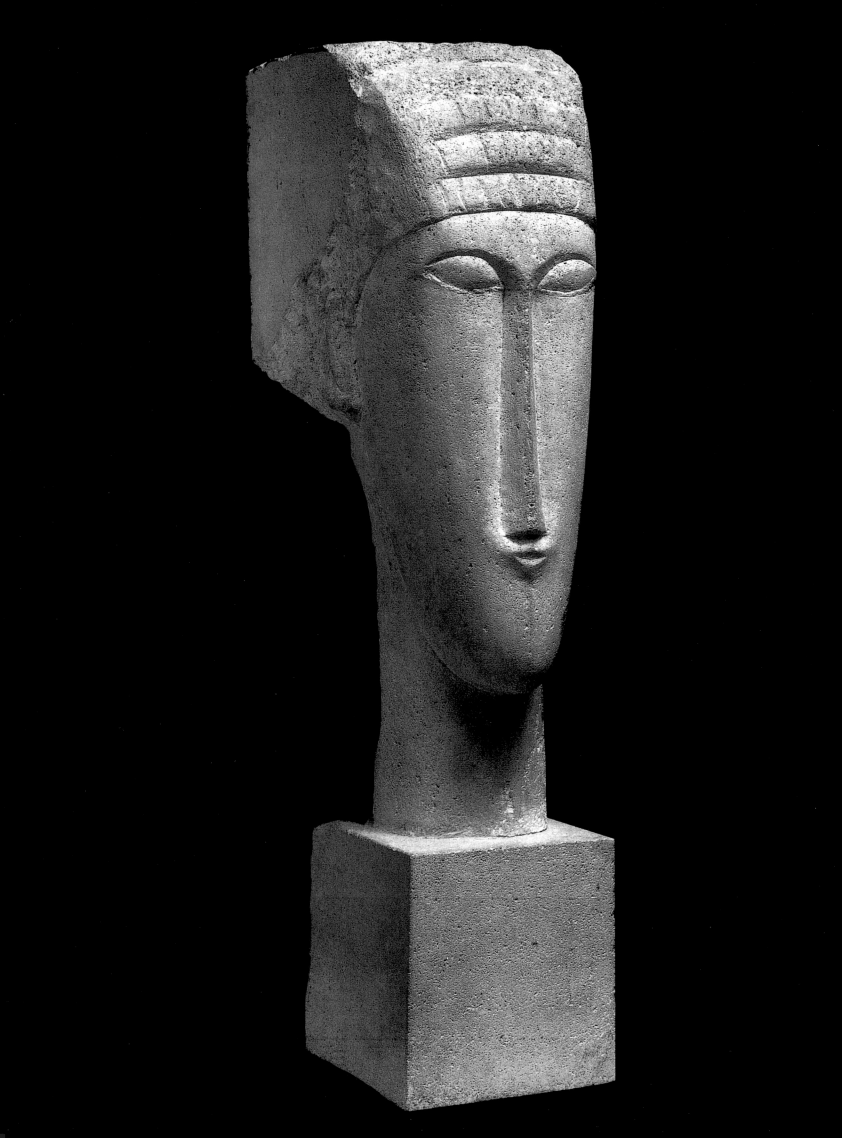

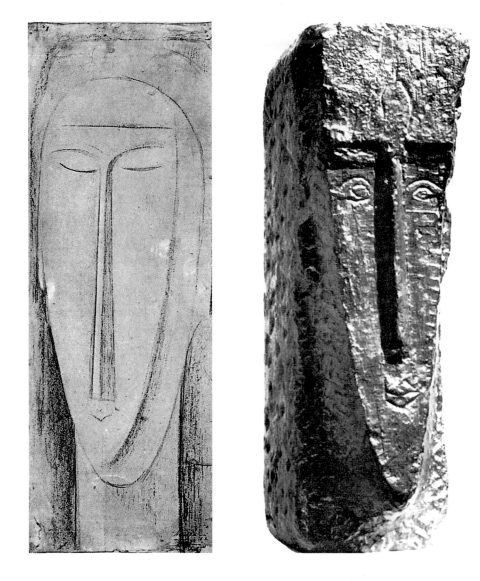

Head of an Idol, c. 2600 BC
Marble, found on Amorgos
Paris, Musée du Louvre

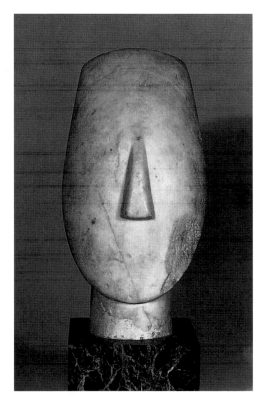

on art before World War I. It was an important component in the criticism of
the apparent progress of civilisation. Artlessness, simplicity, clarity and nat-
uralness were the values ascribed to the *sculptures nègres* and they quickly
became popular collector's items in artistic circles. By the beginning of the
twentieth century, the increasingly technological and materialistic world that
had emerged in many industrialised nations in the course of the nineteenth
century was beginning to produce counter-movements. Gauguin's retreat to
the South Pacific demonstrates one extreme withdrawal from the pressures
of civilisation. The other extreme was to be found amongst the Futurists,
whose chief representative, Marinetti, called for a radical break from all
traditions in a manifesto of 1909 and made the provocative statement that
the racing-car was more beautiful than the *Victory of Samothrace*, one of the
most famous classical sculptures in the Louvre. Both strategies – retreat and
faith in progress – were based on the desire to find something new that
would replace the sense of alienation with one of authenticity. When Picasso
painted *Les Demoiselles d'Avignon* in 1907 (ill. p. 26) he gave expression to
the contempt for what was seen as the over-refined art of the *fin de siècle*.
The rawness of this painting called traditional ways of seeing into question,
while its distortions of perspective lent pictorial expression to a new view of
the world. It was a view characterized by the loss of a secure spatial perspec-
tive, making the relativity of the viewer's standpoint clear to him and con-
veying a sense of instability. All of these typical features of Modernism in
Europe – one need only recall that Albert Einstein had published the major

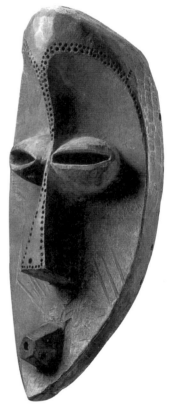

The Red Bust, 1913
Oil on canvas, 81 x 46 cm
Ceroni 38
Private collection

African Mahongwe Mask
Republic of the Congo
Hardwood
Geneva, Barbier-Mueller Collection

tenets of his theory of relativity in 1905 – were depicted by Picasso and the Cubist painters in forms oriented towards the appearance of non-European sculptures.

Modigliani's work as a sculptor was enormously beneficial to his painting. It was through sculpture that he formally arrived at reduction, linearity and abstraction, the components of his own personal, homogeneous pictorial language. This is demonstrated above all by his many drawings of caryatids. Modigliani used this motif from Antiquity to develop his linear style, whereby the softly curving contours of his forms and the emphasis of the two-dimensional became his trademarks. It is very noticeable that these rounded forms seem to be a deliberate counter-position to the angular, geometric forms of the Cubists. Instead of faceted objects, Modigliani used

ILLUSTRATION PAGE 37:
Head, 1911/12
Limestone, 63.5 x 12.5 x 35 cm
London, The Trustees of the Tate Gallery

36

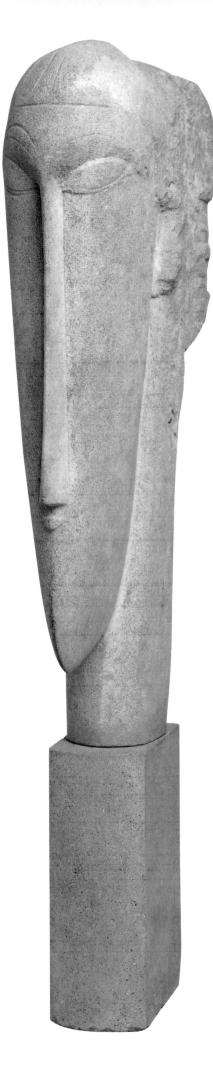

fluid, curving lines which gave the forms their bearing and shape. In their muted colouring, however, Modigliani's caryatid pictures definitely have an affinity with Cubism. In one of the few paintings of this time, the *Caryatid* of 1912 (Kunstsammlung Nordrhein-Westfalen) Modigliani uses only brown and dark-grey tones. His technique has generally become simpler and in some passages it even seems to be deliberately imperfect. The sketch-like elements of this picture are coupled, however, with a few precise lines out of which the female figure develops, resulting in a successful contrast between static and dynamic, between open and closed. The figure has something of the dancer about her and reminds the observer of the mythological origins of the caryatids, who are said to have participated in the famous cult of Artemis of Karuai. Unlike her stone relatives, Modigliani's painted caryatid sculpture does not bear a material load and therefore does not have to be supported by a sturdy base. Her raised arms and bowed head merely "support" the upper edge of the picture and the way the figure is sitting appears strangely unstable. The figure thereby has something intangible about her. In her austere grace she is completely distanced from the real world, is at one and the same time a painting and a sculpture, a stone goddess of the beauty of painting.

When the custons official Henri Rousseau (1844–1910) once visited Brancusi's studio, he uttered the subsequently famous statement: "I see what you want to do; you want to transform the ancient into the modern." In a certain way, this judgement can also be applied to Modigliani. Unlike Brancusi, however, whose work was a radical questioning of the illusionary function of sculpture, anticipating what would later be seen as the problematic nature of sculpted objects, Modigliani's confrontation with the sculpture and forms of non-European cultures led to a lyric, backward-looking quest for "forms full of harmony and beauty". In this phase of his artistic creativity Modigliani was actually in retreat. Unlike Gauguin, he did not physically depart from his familiar, civilised frame of references. Modigliani remained in the metropolis, in Paris, but drew back from the spirit of the age and the avantgarde. Modigliani was an artist who stood contrary to the Parisian art world, who still believed in the beauty of an intact image of man and the possibility of its depiction. He did not offer any systems or theories, preferring simply to paint, draw and sculpt. The Cubist sculptor, Jacques Lipchitz (1891–1973), said about his colleague: "His art was an art of personal feeling. He worked furiously, dashing off drawing after drawing without stopping to correct or ponder. In his work he was obviously guided by a completely intuitive, extremely fine and sensitive feeling, which was perhaps linked to his Italian origins and to his love of the paintings of the Early Renaissance."

Modigliani's approach to art appears removed from the sphere of aesthetic debate. His sculptures were not really responses to the challenges of the genre; rather, as their lyric description as "columns of tenderness" suggests, they arose out of a comprehensive, poetic understanding of art. It is well known that Modigliani was a great lover of poetry, that he could recite entire passages of Dante and Petrarch from memory and often did so, sometimes even while he was painting. In contemporary accounts there are repeated references to the scope and depth of his reading and mention is made of figures such as Mallarmé, Rimbaud, Baudelaire, Nietzsche, Bergson and D'Annunzio. There is unanimous agreement that Modigliani could never be found without a book. Above all, he always had with him a copy of a poem by a poet whom he held in great esteem: Lautréamont's *Chants de Maldoror*. This poem was to become an important source of inspiration for the Surrealists. Perhaps more than anything else, it was the poetry of the nineteenth century that shaped Modigliani's understanding of art; perhaps this is why

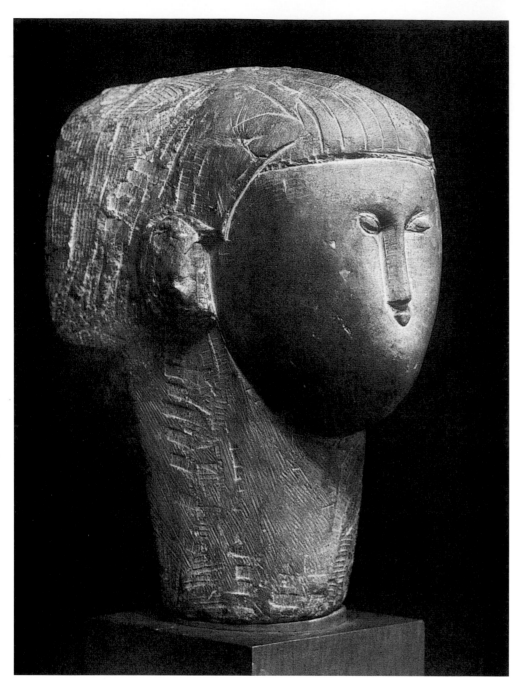

Head, 1910/11
Limestone, height 51 cm
Fort Worth, TX, Gwendolyn Weiner

Beauty

I am beautiful, o mortals, a dream of stone.
And my breast, where each one is wounded, turn by turn,
Inspires the poets to a love
Eternal and mute, like an inanimate existence.

I throne in azure, like a mysterious sphinx,
I have a heart of snow, as white as swans,
I hate movement, it displaces the lines
I never cry and I never laugh.

The poets, in front of my grand poses
Borrowed from proud statues,
Exhaust their days in austere studies.

I must fascinate these docile lovers,
Pure mirrors which make all things more beautiful;
My eyes, my large eyes with the clarity of eternity.

Charles Baudelaire

his works cannot be understood by measuring them according to the standards of the artistic avant-garde of the twentieth century. Yet when one stands in front of Modigliani's distant, stone idols and hears Charles Baudelaire's *Beauty* from his anthology, *Spleen and Ideal*, this poem sounds as if it was made for them, or – not utterly impossible – as if the sculptures were made for the poem.

ILLUSTRATION PAGE 39:
Bride and Groom, 1915/16
Oil on canvas, 55.2 x 46.3 cm
Ceroni 55
New York, Museum of Modern Art
Gift of Frederic Clay Bartlett

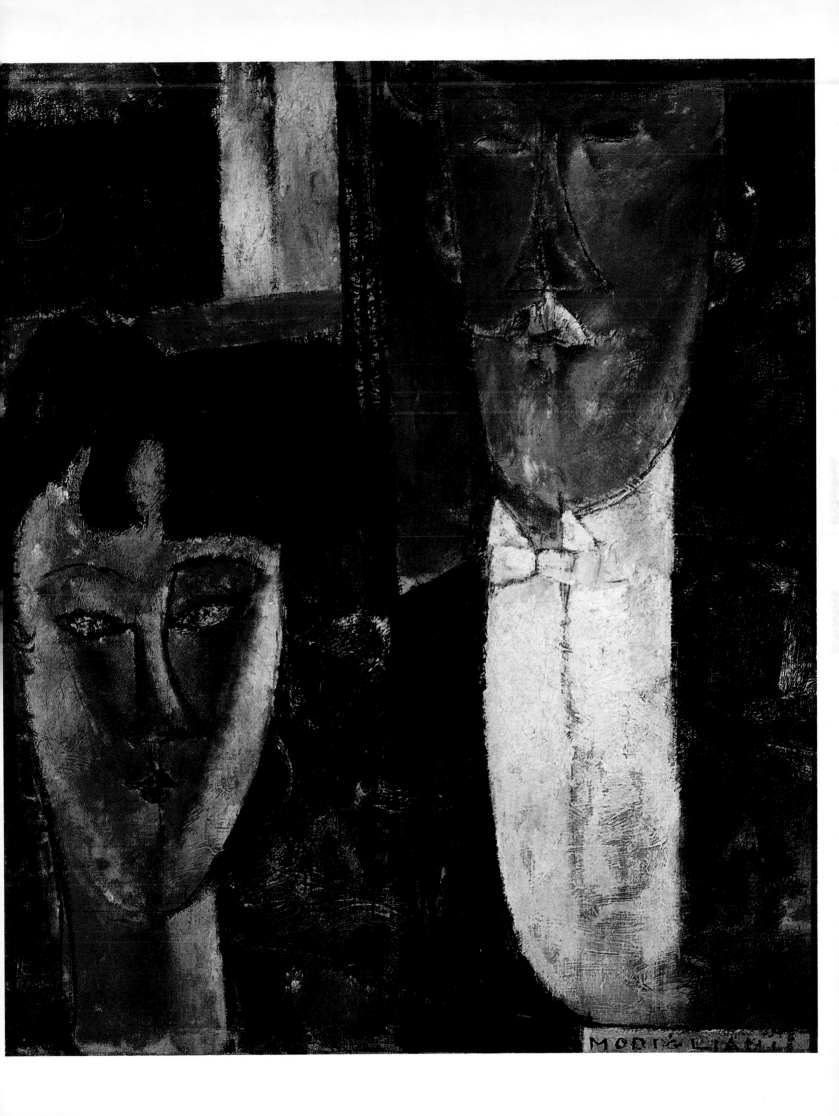

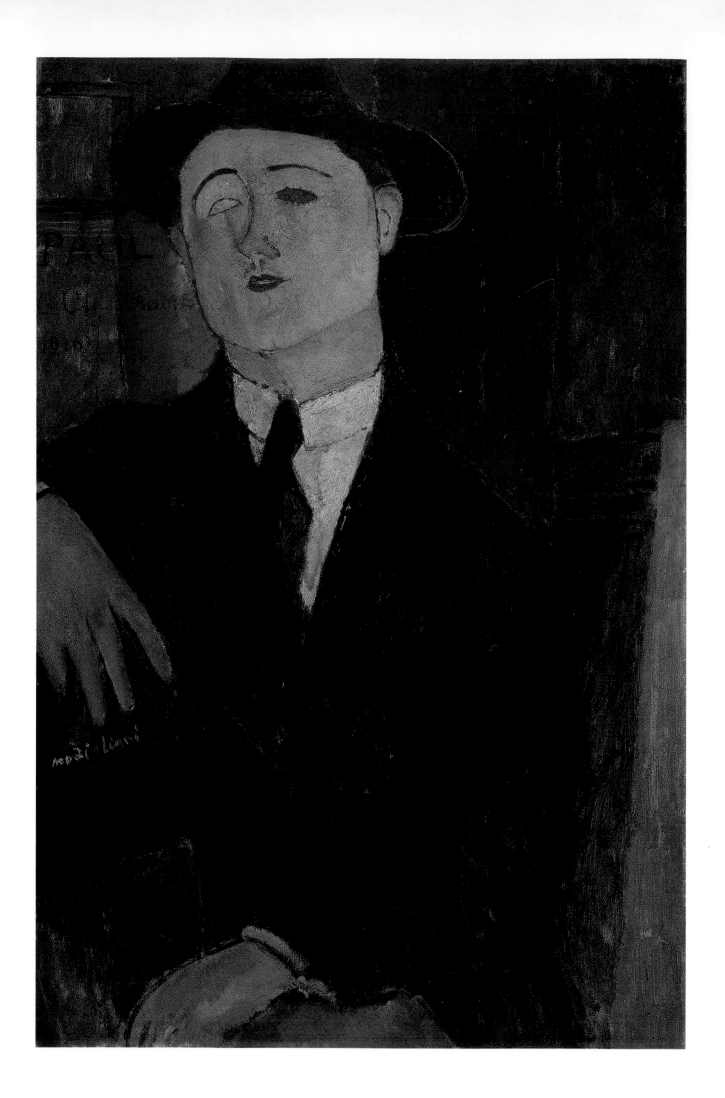

He was Our Aristocrat

Pierrot, 1915
Oil on cardboard, 43 x 27 cm
Ceroni 52
Copenhagen, Statens Museum for Kunst

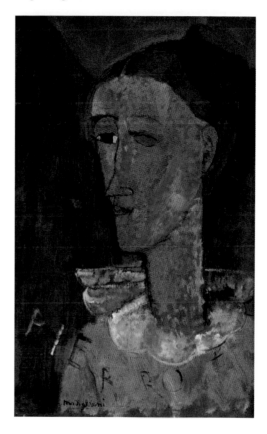

Works of art are the product of a complicated system of social interaction between artists, patrons, critics, and a public that is as broad as possible, all influencing each other in their assessments and behaviour. In the years before World War I, Paris was a prime example of how such interrelated influences can emerge and flourish. The highly developed infrastructure of the worlds of art and culture was a prerequisite for the birth of what we today call the avant-garde. Like any stylistic movement, the avant-garde was the leading figures of the day with their clear objectives and manifestos; it was an amalgam of artistic directions and a tight network of personal contacts. From today's perspective, this development appears to have a greater stringency than was actually the case. The tendency of art history to classify everything creates the impression that this era was a series of art "isms" in which opposing groups – Fauvists, Cubists, Futurists, Orphists and Dadaists – trod the path of artistic progress with absolute consistency. Perhaps it has something to do with the military origins of the term avant-garde which makes portrayals of the development of modern art often sound like depictions of military battles and defeats. At the end of his long life, Picasso said: "When we discovered Cubism, we did not have the aim of discovering Cubism. We only wanted to express what was in us." This is, of course, a slight understatement, for at the time art was not purely concerned with the pursuit of high ideals, but also with success and recognition, with the exhibition and sale of pictures. Nonetheless, Picasso's statement does serve to reveal the distance between historical phenomena and the way in which they are actually experienced at the time. Therefore, we should put later descriptions to one side and imagine Paris in the pre-war years as a meeting-place for fascinating people of varied origins, as a relatively small melting-pot of artists, writers, musicians and critics, who all – whether they were taken up into the Mount Olympus of classical Modernism or have by now passed into obscurity – engaged in lively interchange and played their roles with *élan* as they set about designing anew the art of the young twentieth century.

When the war broke out, everything changed. Escape, emigration, conscription, and later, injury and death destroyed cultural affiliations in Paris as they did everywhere in Europe. Among the circle of artists in Paris, after August 1, 1914, those who had been spared military duty first had a feeling of abandonment but then made the best of it, slowly coming to terms with the situation. Modigliani, who at the outbreak of the war was apparently an enthusiastic volunteer for the front, was rejected on health grounds and was amongst those who spent the war years in Paris. After his phase as a sculptor he began to work with oils again around 1914 and his art now became ever more independent. The realisation of his personal poetic vision increased the

ILLUSTRATION PAGE 40:
Portrait of Paul Guillaume, 1916
Oil on canvas, 80.5 x 54 cm
Ceroni 108
Milan, Civico Museo d'Arte Contemporanea

The young art dealer Paul Guillaume, who opened his own gallery in the spring of 1914 in Faubourg Saint-Honoré, exhibited a number of then unknown artists such as de Chirico, Derain and Delaunay. Max Jacob drew his attention to Modigliani and he began to lend him support in 1914. In so doing, he replaced Dr Paul Alexandre, with whom Modigliani had lost contact after the outbreak of the war. Guillaume and Modigliani, both exempted from military service for health reasons, spent the war years in Paris.

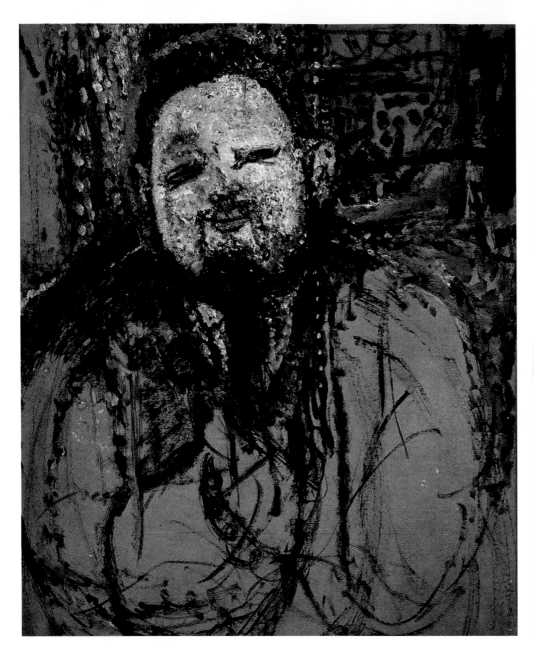

Portrait of Diego Rivera, 1914
Oil on cardboard, 100 x 79 cm
Ceroni 41
São Paulo, Museu de Arte

The Mexican painter came to Paris in 1911
and was quickly accepted into Picasso's
circle. Modigliani painted a number of por-
traits of Rivera, who in 1929 married the
painter Frida Kahlo and in the 1930s became
one of the major representatives of Mexican
mural painting. The revolutionary emotive-
ness and fiery temperament of the "impetuous
Indian" have been captured by Modigliani in
strong, free patches of colour.

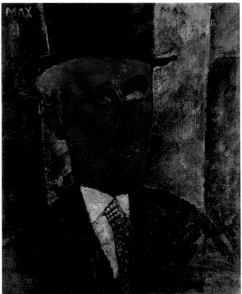

Portrait of Max Jacob, 1916
Oil on canvas, 73 x 60 cm
Ceroni 104
Düsseldorf, Kunstsammlung Nordrhein-
Westfalen

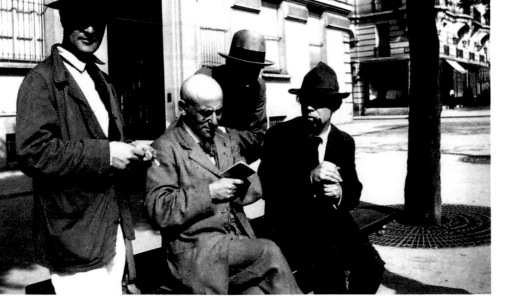

Jean Cocteau
Modigliani, Max Jacob, André Salmon and
Ortiz de Zarate (from left), 1916

42

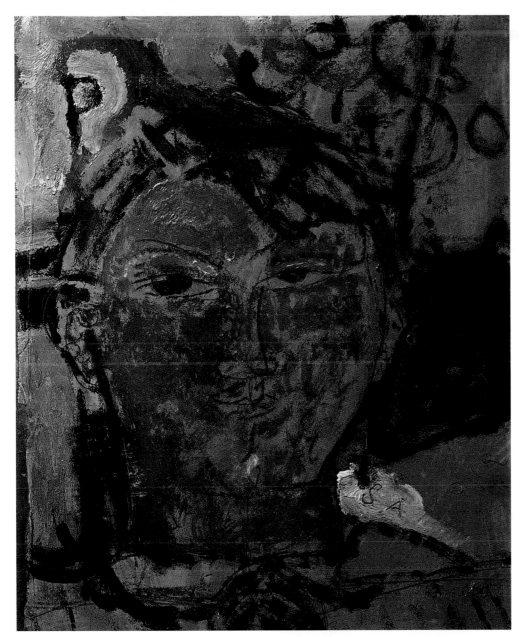

Portrait of Pablo Picasso, 1915
Oil on cardboard, 34.5 x 26.5 cm
Ceroni 96
Private collection

Pablo Picasso, 1914
Lead pencil on paper, 22.5 x 27 cm
Antibes, Musée Picasso

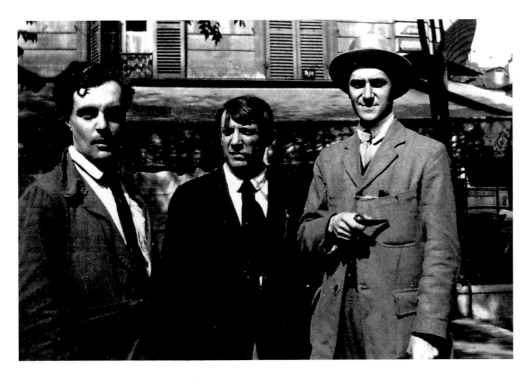

Jean Cocteau
Modigliani, Picasso and André Salmon (from left), 1916
"A day with Picasso". On a Sunday in August of wartime 1916, an illustrious group met in front of the Rotonde on Montparnasse and was photographed by Jean Cocteau. Modigliani is standing on the left beside Picasso, whose portrait he had painted the year before. On the right is André Salmon, who would later write the novel *Montmartre – Montparnasse. The Life of Amedeo Modigliani*. Using Cocteau's 21 photographs, Billy Klüver has reconstructed this day in minute detail (see also p. 42).

43

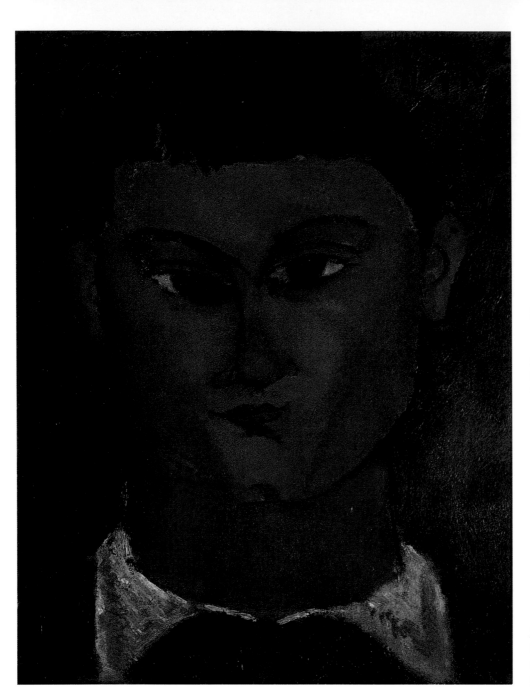

Portrait of Leopold Zborovski, 1917
Chalk on paper, 31 x 24.9 cm
Troyes, Musée d'Art Moderne

Portrait of Moïse Kisling, 1915
Oil on canvas, 37 x 28 cm
Ceroni 98
Milan, Pinacoteca di Brera

ILLUSTRATION PAGE 45:
Portrait of Leopold Zborovski
1918
Oil on canvas
46 x 27 cm
Ceroni 227
Private collection

The Polish poet, known as "Zbo" to his friends, had been living in Paris since 1914 and was active as an art dealer. He and his wife Anna gave their self-sacrificing help to Modigliani, whose health steadily deteriorated in his last years. When Modigliani moved out of the flat he shared with Beatrice Hastings on the Rue Norvain on Montmartre, the Zborovskis gave him a place to live and also let him use a room in their flat as a studio.

distance between his own work and that of other possible influences. Modigliani consistently forged his own artistic path, earning him the reputation of the great, isolated loner. Apart from the series of nudes from 1917 and a few landscapes, Modigliani now devoted himself entirely to the portrait. His portrait paintings can be divided into two groups: paintings of friends and acquaintances, which can often be identified by the inscribed names, and portraits of anonymous models who have been stylised into diverse types. The portraits of Parisian friends and acquaintances, however, which made up the bulk of his work immediately after his phase as a sculptor, make the lone wolf Modigliani into a chronicler of the art scene that still remained on Montmarte and Montparnasse during the war. The first unmistakable "Modiglianis" are portraits of Jacques Lipchitz and his wife Berthe (ill. p. 46), Max Jacob (1876–1944; ill. p. 42), Jean Cocteau (1889–1963; ill. p. 49) and Chaim Soutine (1893–1943; ill. p. 47). These are names that are invariably cited when one speaks of the Parisian avant-garde, and are thereby also inseparably linked to the name Modigliani. Although he did not have the same artistic objectives, this reciprocal link finally guaranteed Modigliani's entry

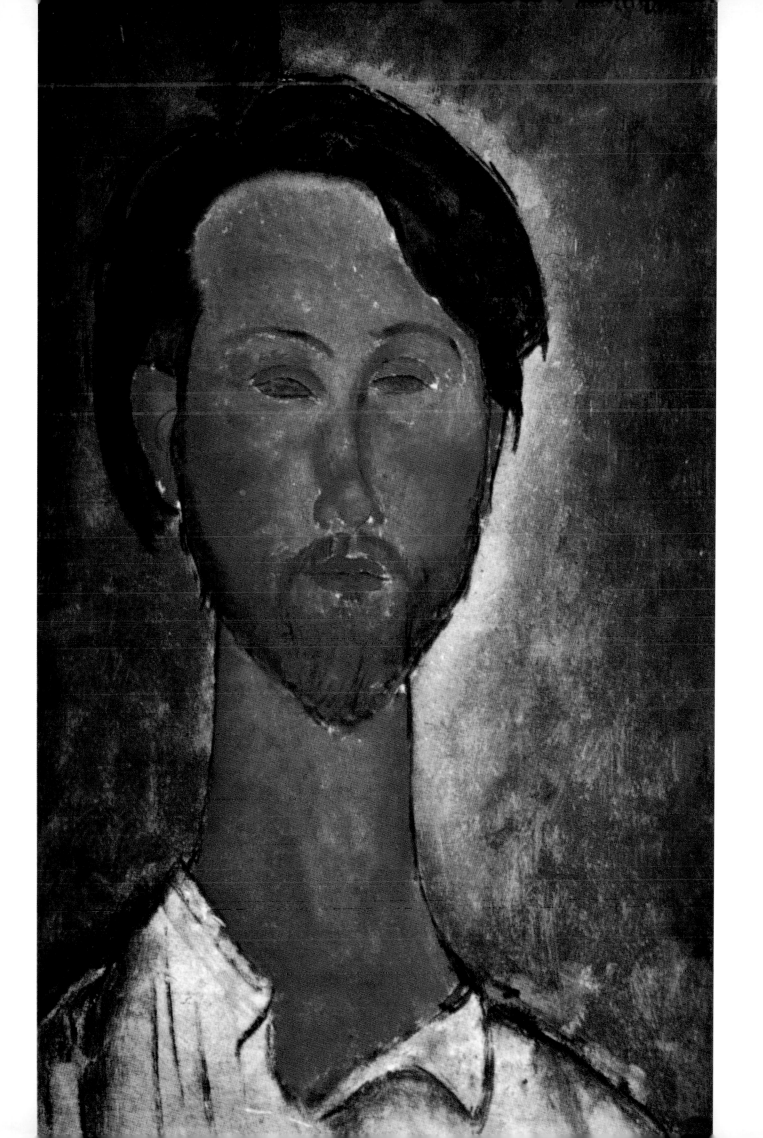

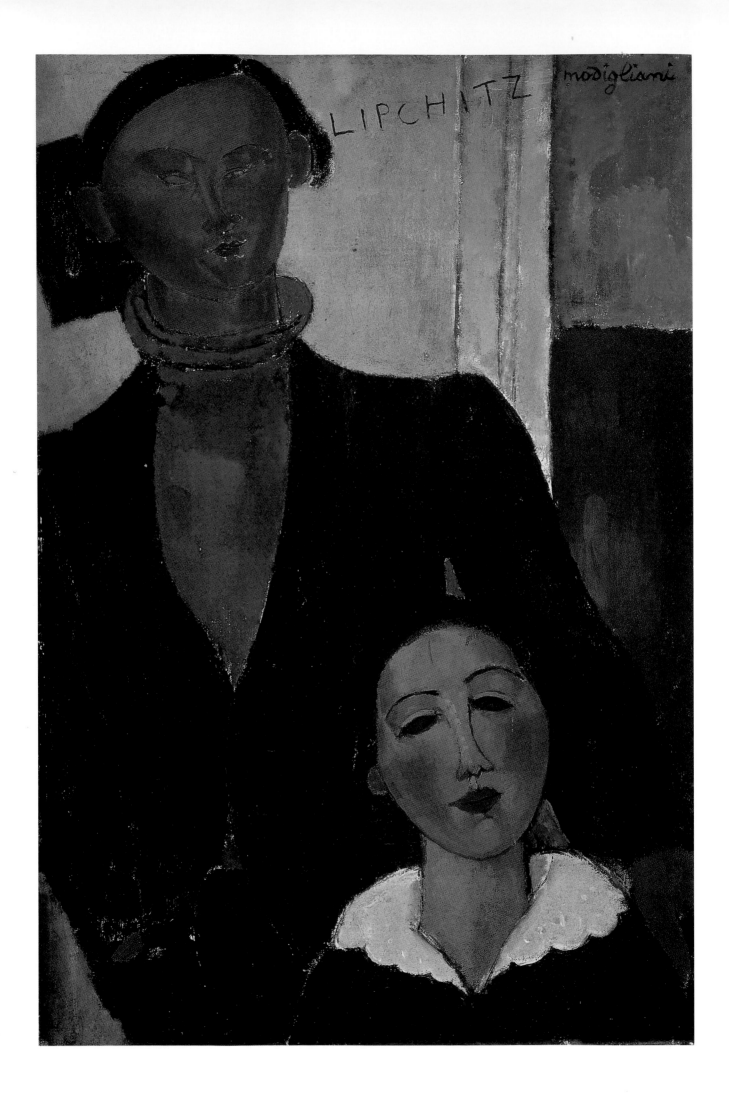

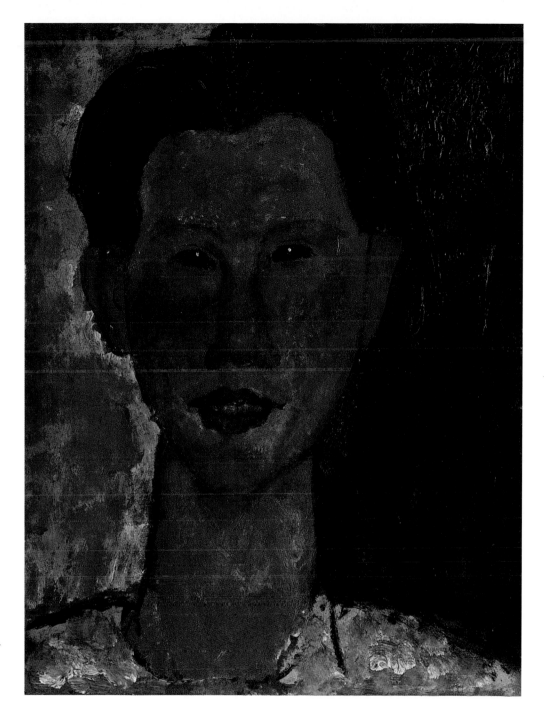

Portrait of Chaim Soutine, 1915
Oil on panel, 36 x 27.5 cm
Ceroni 97
Stuttgart, Staatsgalerie

The painter Chaim Soutine, originally from Lithuania, came to Paris in 1913, where he lived a very humble life in a circle of other Jewish émigré artists, such as Chagall, Lipchitz and Kisling. Soutine, who found his personal, expressive style of painting in 1918, was one of Modigliani's closest friends and greatest admirers.

ILLUSTRATION PAGE 46:
Jacques and Berthe Lipchitz, 1916
Oil on canvas, 80.2 x 53.5 cm
Ceroni 161
Chicago, The Art Institute of Chicago
Helen Birch Bartlett Memorial Collection
1929.221

into the avant-garde. It ensured him his singular position in artistic Modernism, as it existed in Paris, and played a substantial role in contributing to the Modigliani legend. The writer André Salmon (1881–1969), for example, who can be seen beside Picasso and Modigliani on a photograph taken in 1916 by Jean Cocteau (ill. p.43), later wrote a long novel in which he made Modigliani the main figure amongst the artists of Montmartre and Montparnasse.

The first pictures executed by Modigliani after his sculptures – the portrait of the sculptor Henri Laurens (1885–1954) and that of Picasso (1915, ill. p.43) – show a fleeting, free brushwork style and a very restrained use of colour. As in the paintings of the caryatids, the surface of the picture is not entirely covered, so that one sees the cloth of the canvas and the eye is caught by exactly those areas where the painting begins and ends. Only a short time later, Modigliani covered his canvases completely, often sealing them with several layers of varnish. These portraits were painted with the help of the many drawings and sketches of his acquaintances which Modi-

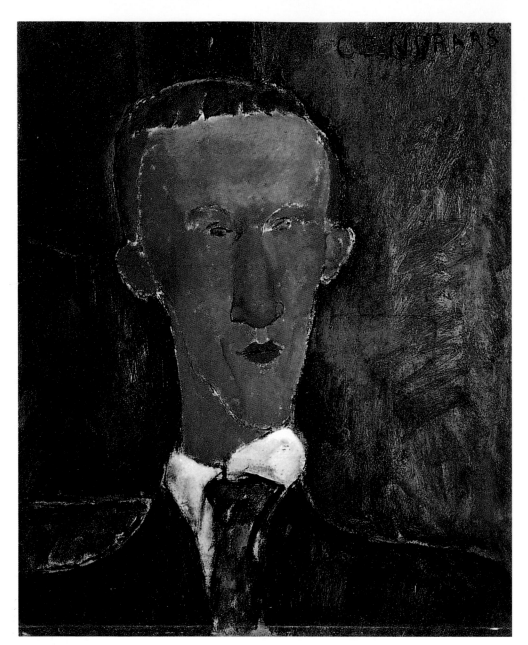

Portrait of Blaise Cendrars, 1918
Oil on cardboard, 61 x 50 cm
Ceroni 164
Private collection

Moïse Kisling
Portrait of Jean Cocteau, 1916
Oil on canvas, 73 x 60 cm
Geneva, Petit Palais, Musée d'Art Moderne

gliani took every opportunity to make. Some of the subjects also sat for him and it was not unusual for Modigliani to use photographs. For example, after many sittings for their portrait, it was finally the wedding photograph of the Lipchitz' that inspired Modigliani's painting of the couple (ill. p. 46).

The development of photography, as well as the desire for artistic autonomy, meant that by the beginning of the twentieth century the genre of portraiture had lost much of its original function of depicting the likeness of a person. Modigliani is the only artist of classical Modernism who still concentrated almost exclusively on the actual subject. And yet the portrait had once been considered the source of painting. The Renaissance art historian, Giorgio Vasari (1511–1574), relates a legend, *The Daughter of Butades*, on the emergence of painting. It was a legend that would remain familiar well into the nineteenth century. It tells how in the distant past a young woman, grief-stricken at having to part from her lover, sketched the outline of his silhouette on a wall, thereby at least retaining a picture of him. What is interesting about this myth is that it defines painting as the depiction of something which is past, something which places before the eye that which is absent, and finally that it originates from love and offers comfort.

Portraits therefore have the function of reminding one of a person and of

ILLUSTRATION PAGE 49:
Portrait of Jean Cocteau, 1916
Oil on canvas, 100 x 81 cm
Ceroni 106
Princeton, NJ, The Art Museum Princeton
University, lent by the Henry and Rose
Pearlman Foundation

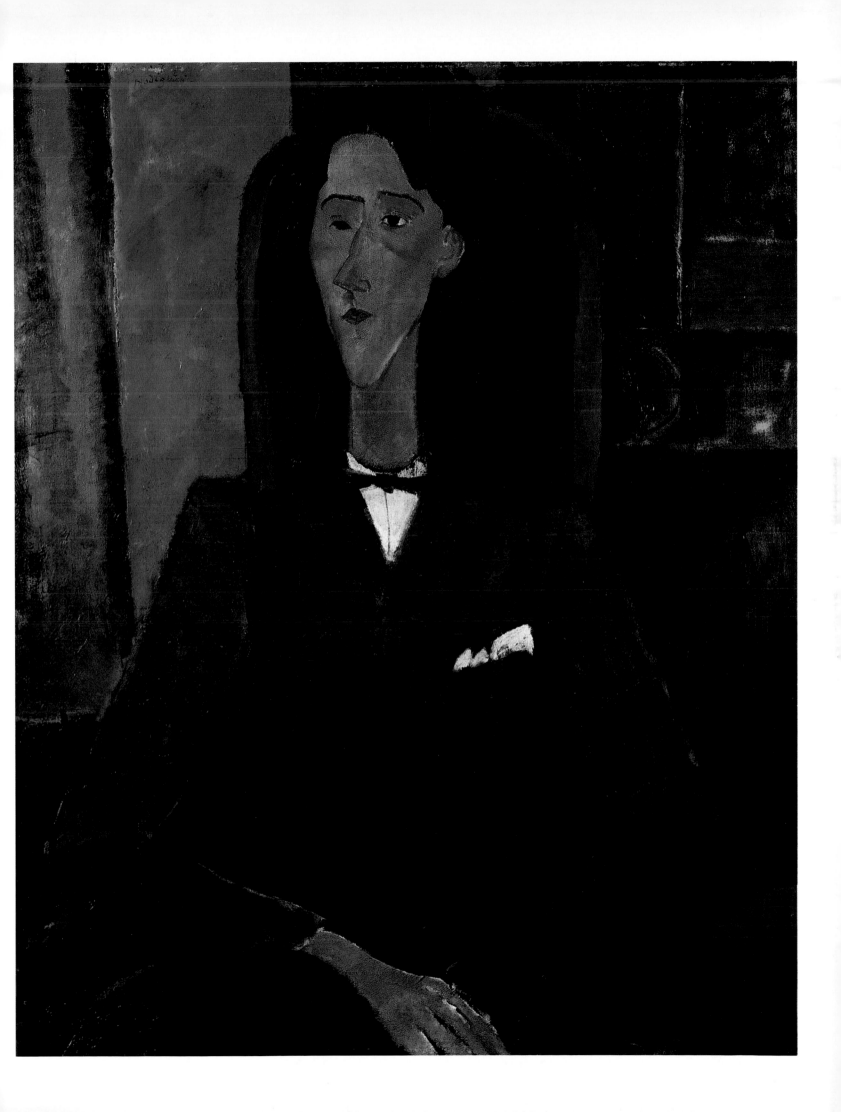

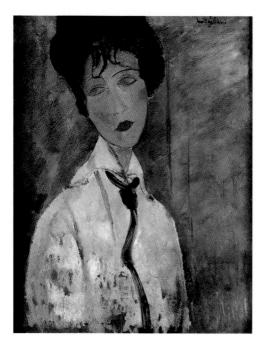

Portrait of a Woman with Black Cravat, 1917
Oil on canvas, 65.4 x 50.5 cm
Ceroni 297
Tokyo, Collection Fujikawa Galleries Inc.

ILLUSTRATION PAGE 51:
Portrait of Anna Zborovska, 1917
Oil on canvas, 55 x 33 cm
Ceroni 160
Rome, Galleria Nazionale d'Arte Moderna

depicting them. This demands a certain similarity between the portrayed subject and their likeness, a similarity which can lie both in the external physiognomic features as well as in the symbolic depiction of the subject's character. Every portrait, however, says as much about its painter as its subject. The portrait can thus be considered as that genre of painting in which two individuals are eternally fused. In Modigliani's portraiture, this fusion is particularly conspicuous. Over the years, he developed a number of stylistic features, such as the strong emphasis he places upon lines and the surfaces that they enclose, his elegant elongation and distortion of bodies, and the almond shapes which he gives the often asymmetrically-placed eyes. The schematic stylisation of facial features is each time applied to the persons depicted. These are often named in the pictures in awkward handwriting. The unmistakable pictorial language in which Modigliani captures his subjects passes, in the writing of their names, into the literal form of the letters of the alphabet. The inscriptions, in emulation of the inscriptions on Renaissance portraits, indicate that, after the demanding process of painting a portrait, the distance between artist and model has once again been established.

Modigliani's view of the people captured in his portraits changed in the course of his work. In the portraits of Dr Paul Alexandre (ill. p. 14) and the Baroness de Hasse de Villers from 1909 (ill. p. 17), the status and character of the subjects can be read from the way in which they are presented. In a more expressive portrait, such as that of the Mexican painter Diego Rivera (1866–1957, ill. p. 42), Modigliani's brushwork seems to have been influenced by his subject's powerful appearance and legendary volcanic temperament. In his subsequent portraits, which show an increasing stylistic smoothness, Modigliani is more interested in outward appearances than in character. In his two portraits of his friend, the poet Max Jacob (ill. p. 42), Modigliani brings out his distinctive features – his bald head, unusually large nose, narrow face and small mouth – with great, almost plastic, clarity. The individual forms are outlined with strong contours, resulting in a contracted view, visibly influenced by Cubist painting. In other portraits from the years 1915/16 there is a similar geometric stylisation, reminiscent of Modigliani's sharp-edged sculpted heads. In the painting *Bride and Groom* (ill. p. 39), Modigliani's play of lines almost results in a caricatured depiction of the bridal couple. In his emphasised rendering of mouth, nose and eyes, Modigliani's portrait of Beatrice Hastings also reveals a light irony. The English writer, Beatrice Hastings, who was Modigliani's mistress between 1914 and 1916, is presented as *Madam Pompadour* in this painting (ill. p. 33). The reference to Louis XV's most famous mistress and her transformation into an English "madam" was meant to wittily depict Hastings' role in Modigliani's life. This explains the exaggerated characterisation of the eccentric poetess as well as her very old-fashioned hat, whose origins are as bourgeois as those of the Marquise de Pompadour, elevated by the king to the aristocracy – much to the horror of the Versailles court. The playful and unofficial character of this portrait resulted from the close – and, as described by Hastings – dramatic relationship between the painter and his model. She had come to Paris in April 1914 to write a column entitled "Impressions de Paris" for the London-based journal *The New Age*. English readers were apparently just as interested in gossip about Parisian Bohemia as in discussions of current events. Under cover of a pseudonym, Beatrice Hastings delivered many casually-written pieces, revealing her intimate knowledge of the scene. She also offered a candid account of her impression of Modigliani: "A complex character. A swine and a pearl. Met him in 1914 at a crémerie. I sat opposite him. Hashish and brandy. Not at all impressed.

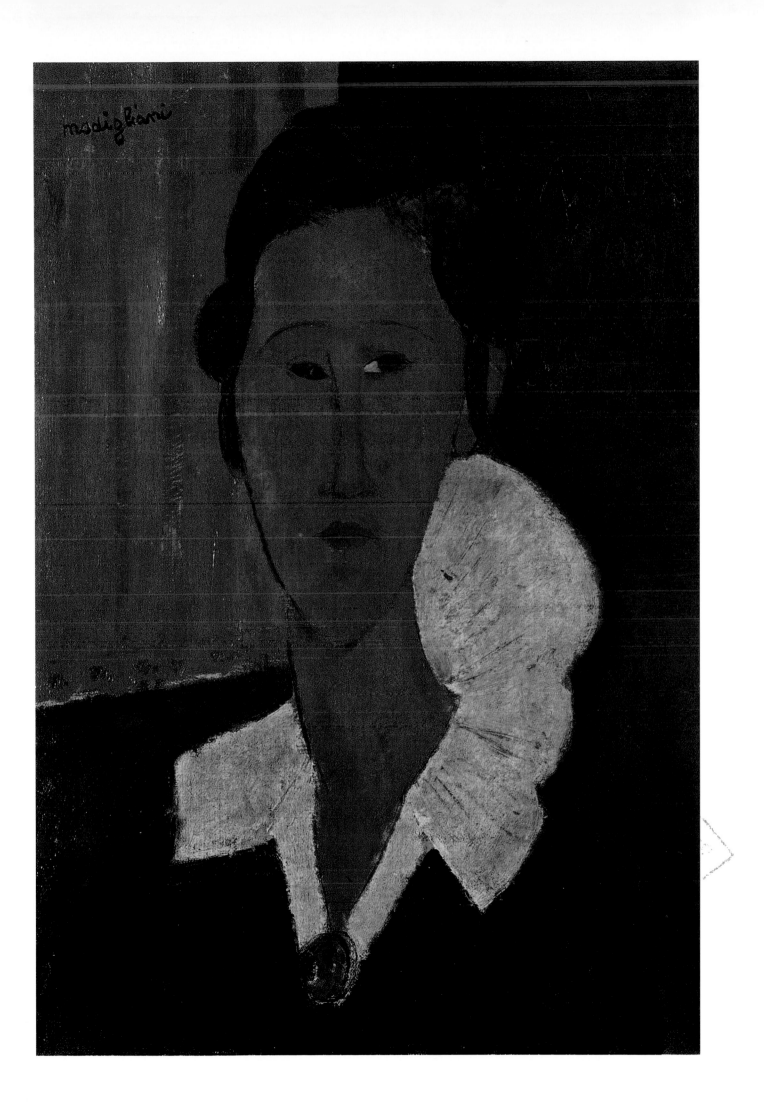

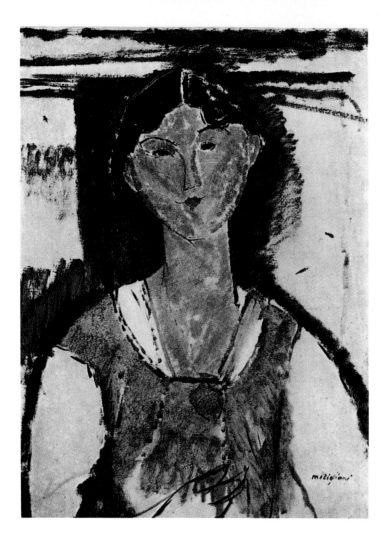

Study for a *Portrait of Beatrice Hastings*
1915
Oil on cardboard, 69 x 49 cm
Ceroni 77
Milan, Fondazione Antonio Mazzotta

TOP RIGHT:
Head, 1915
Oil on cardboard, 54 x 42.5 cm
Ceroni 50
Paris, Musée National d'Art Moderne
Centre Georges Pompidou

Didn't know who he was. He looked ugly, ferocious and greedy. Met him again at the Café Rotonde. He was shaved and charming. Raised his cap with a pretty gesture, blushed and asked me to come and see his work. And I went. He always had a book in his pocket. Lautrémont's *Maldoror*. The first oilpainting was of Kisling. He had no respect for anyone except Picasso and Max Jacob. Detested Cocteau. Never completed anything good under the influence of hashish."

In the portraits that Modigliani made of Beatrice Hastings and in the two portraits of Max Jacob, he developed an incisive method of portrayal that is above all indebted to his draughtsmanly use of line, giving concise, precise expression to the subject's essential characteristics. Other portraits, such as those of Chaim Soutine (ill. p. 47) or Moïse Kisling (1891–1953, ill. p. 44), show a painterly treatment of the subject. In these paintings, Modigliani reduces the information about the person to a minimum. His two Eastern European friends are depicted free of all extraneous details. On the whole, one notes an increasing tendency towards simplification and reduction in Modigliani's approach to portraiture. Max Jacob linked this to the character of the Italian artist: "For Dedo, simply everything was directed towards purity in art. His unbearable pride, grim ingratitude, arrogance; all of these expressed nothing else but his longing for crystalline purity, [nothing but] an absolute honesty towards himself in life as in art, and this did not exclude trust which had been placed in him. He was cutting but also as fragile as glass and, so to speak, as inhuman as glass. And that was very characteristic of this age, which spoke of nothing but purity in art."

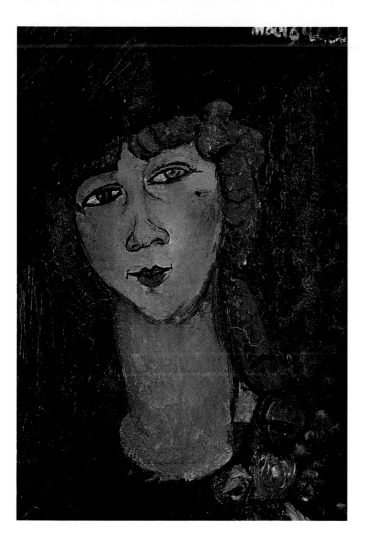

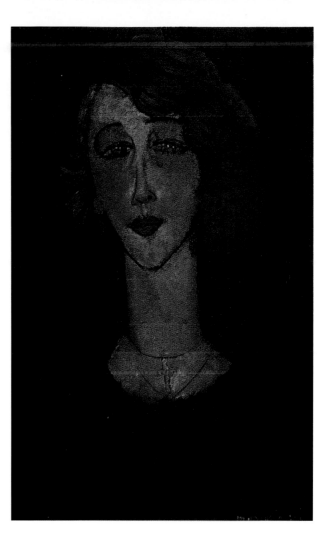

Renée the Blonde, 1916
Oil on canvas, 61 x 38 cm
Ceroni 137
São Paulo, Museu de Arte

TOP LEFT:
Lolotte, 1916
Oil on canvas, 55 x 35.5 cm
Ceroni 139
Paris, Musée National d'Art Moderne
Centre Georges Pompidou

What Max Jacob describes as purity is visible in Modigliani's paintings as the art of omission. In fact, by this point his portraits are almost easier to describe if one lists what they do not show. The intense concentration on the subject's physiognomy means that all decorative attributes, distinguishing gestures, suggestions of an existing space or narrative elements are left out. In this rigorous, self-imposed reduction, Modigliani's paintings really were unique for their time. There are approximate models to be found, however, in the art of earlier centuries: in that of the Italian Renaissance, an obvious source of inspiration for Modigliani, but also in the portraiture of Netherlands masters such as Frans Hals (1581/85–1666) and Rembrandt (1606–1669). Max Jacob's "purity" manifested itself in Modigliani's portraits as a leaning towards what lay outside of time, towards the eternally valid and thus to the classical. A persuasive example of this can be found in a comparison of the portraits of Jean Cocteau – the young all-round talent who had become known through his work with Diaghilev's *Ballets Russes* – painted by Modigliani (ill. p.49) and Moïse Kisling (ill. p.48). Both paintings were done at the same sitting in Kisling's studio in the Rue Joseph Bara. While Kisling's portrait shows Cocteau within the ambience of the actual room, Modigliani lifts him into spheres removed from reality. Cocteau is brought closer to the viewer in a half-length portrait, lending prominence to his striking features. Cocteau is given a more upright pose here than in Kisling's portrait. The chair's high back reminds one of a throne and emphasises the aristocratic appearance of the 27-year-old, a promising artist who frequented the *salons* of the Right Bank.

"Modigliani's drawing is suffused with the utmost elegance. He was our

aristocrat", was what Jean Cocteau wrote about Modigliani – giving no hint of the oft-rumoured enmity between the two. In fact, some parallels can be drawn between the artist inspired by the Bohemian life and the one inspired by Dandyism. In their elegant drawings, both had a tendency towards a decorative refinement of line. Moreover, Cocteau's affinity with Modigliani is expressed in a sensitive description of his art. "His curved line, which is often so pale and fine that it appears to be the ghost of a line, moves with the suppleness and grace of a Siamese cat and is never in danger of becoming thick or awkward. It was not Modigliani who distorted and lengthened the face, who established its asymmetry, knocked out one of the eyes, elongated the neck. All of this happened in his heart. And this is how he drew us at tables in the Café de la Rotonde; this is how he saw us, loved us, felt us, disagreed or fought with us. His drawing was a silent conversation, a dialogue between his lines and ours. And from this tree, which stood so sturdily on its corduroy-clad legs, this walking tree, so difficult to uproot once it had taken root, the leaves fell and covered the ground of Montparnasse. If at the end, his models began to resemble each other, then this was in the same way as Renoir's young girls resemble each other. We were all subordinated to his style, to a type that he carried within himself, and he automatically looked for faces that resembled the configuration that he required, from both man and woman. Resemblance is actually nothing more than a pretext that allows the painter to confirm the picture that is in his mind. And by that one does not mean an actual, physical picture, but the mystery of his own genius."

Cocteau's literary portrait of Modigliani once more emphasises the great stylisation of the portraits, which began to demonstrate an ever more perfect linear control. At the same time, Cocteau gives a subtle impression of Modigliani's position within the Parisian art scene. As a painter, he was not one of its leading figures but always in the proximity of such figures. To put it succinctly: he was a character. Everybody knew him, everybody had their portrait painted by him, his art was popular, even if nobody yet knew exactly what was so special about it.

Despite the general air of depression, the first years of the war were more successful for Modigliani than all the years preceding it. There is no trace at this time of the legendary isolation that would be described in so many monographs. In 1914 Max Jacob introduced him to the young art dealer Paul Guillaume, who had opened a gallery on the Rue du Faubourg-St.-Honoré on the Right Bank shortly before the outbreak of war. He was exhibiting artists still virtually unknown, such as the Russians Natalia Goncharova (1881–1962) and Mikhail Larionov (1881–1964), as well as Giorgio de Chiroco (1888–1978) and Francis Picabia (1879–1953). Paul Guillaume bought and sold Modigliani's pictures and had him participate in many group exhibitions at his gallery, thereby supplying the artist with crucial support. He did not, however, put him under contract nor hold a one man show of the Italian's work during his lifetime. Like de Chirico and Derain, Modigliani painted his most important patron in oil a number of times. In the Milan portrait (ill. p. 40) Guillaume, hat pushed back and tie slightly askew, seems casual and relaxed. In another portrait that Modigliani painted of Guillaume, now in a private Paris collection, the inscription NOVO PILOTA appears in the lower left-hand corner, a compliment that compared Guillaume's progressive spirit with that of the aviation pioneers. Guillaume's feel for innovations in the art world can be compared with that of Vollard or Kahnweiler, although he never did achieve their fame – he shot himself in 1934 at the age of forty-three. His collection of African sculpture was attract-

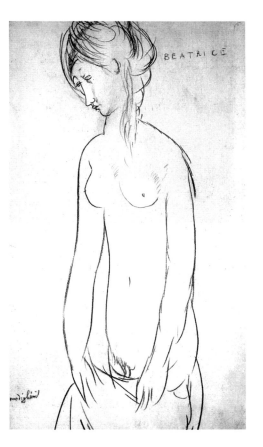

Beatrice, 1915/16
Charcoal on paper, 55 x 38 cm
Private collection

ILLUSTRATION PAGE 55:
Beatrice Hastings, 1915
Oil on canvas, 81 x 54 cm
Ceroni 81
Private collection

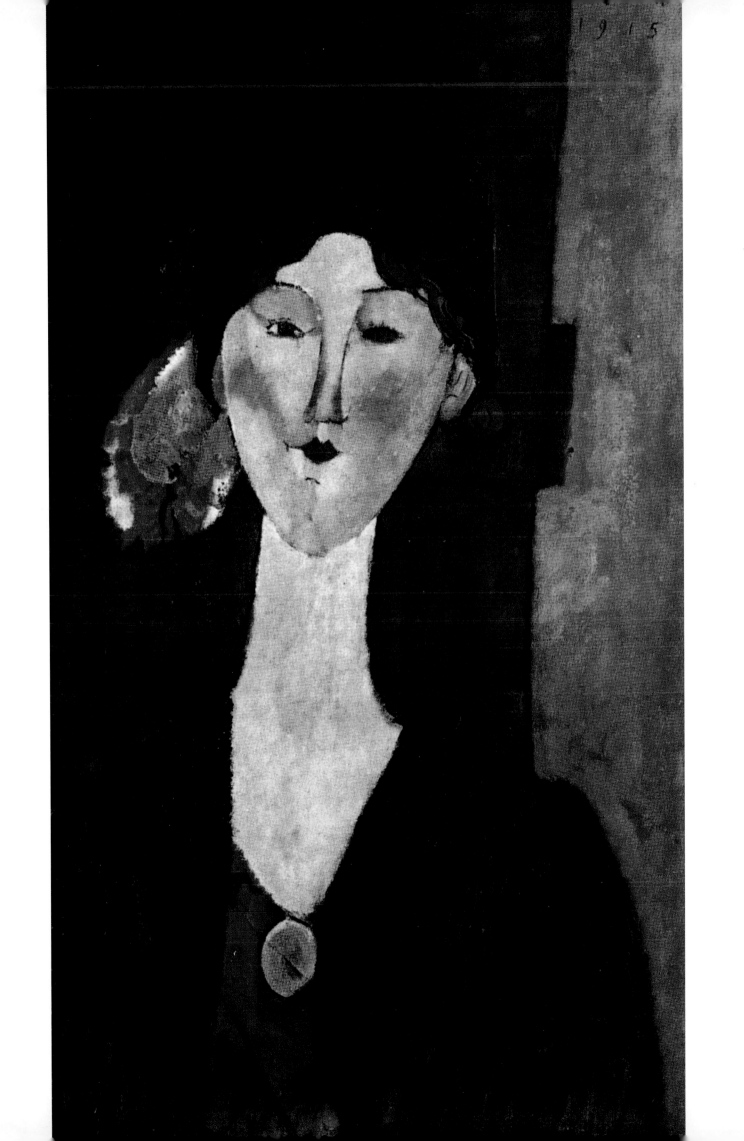

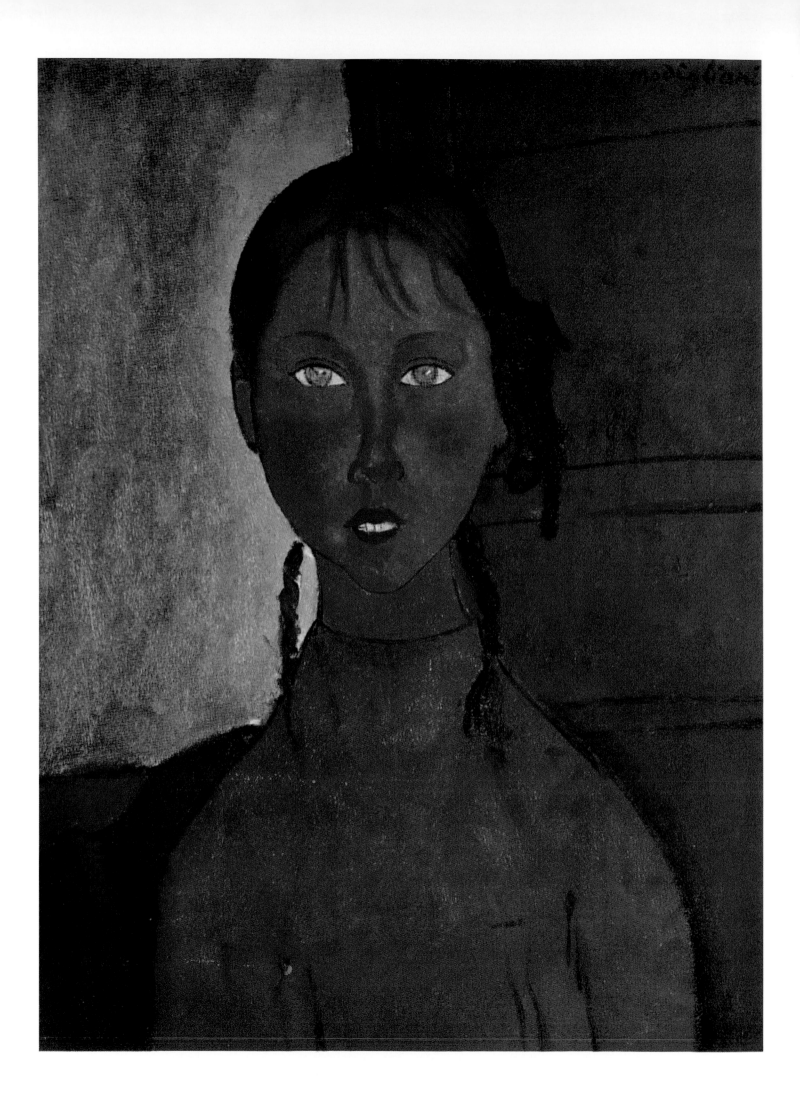

ing attention years before the outbreak of World War I. As owner of his own gallery he became one of the most important dealers in *sculptures nègres.* Paul Guillaume supplied Guillaume Apollinaire with his large collection of "Oceanic fetishes", for example. Although Paul Guillaume's relationship with Modigliani was not as close as with other artists, he later played a decisive role in establishing Modigliani's fame in the United States. Through Guillaume's acquaintance with Dr Albert C. Barnes, a number of paintings by artists of the École de Paris were acquired for the latter's collection in Merion, near Philadelphia, in 1923. They thereby also attracted the attention of American art museums. Modigliani's early death meant that he himself would never enjoy the fruits of this success, for as with Chaim Soutine, Guillaume's picture sales to the American market would have made Modigliani a wealthy man overnight.

When Modigliani made the acquaintance in 1916 of the Polish poet Leopold Zborovski (1889–1932), he met the greatest admirer of his art in his lifetime, and one who became an understanding and impassioned friend. Zborovski, who had come to Paris in 1914 to study literature, earned his living selling books and prints. As an art dealer, Zborovksi did not have Guillaume's important contacts and certainly none of his feeling for the avant-garde, but it was he and his wife Anna who offered Modigliani their self-sacrificing support in the last years of the artists's life. Modigliani, who painted the couple in a number of portraits (ill. p. 44, 45, 51), received a daily allowance and painting materials from Zborovski, and the couple also allowed him to place his easel in their living-room. Zborovski is also credited with employing professional models for Modigliani, thereby having a major part in the series of nudes which Modigliani executed in 1917.

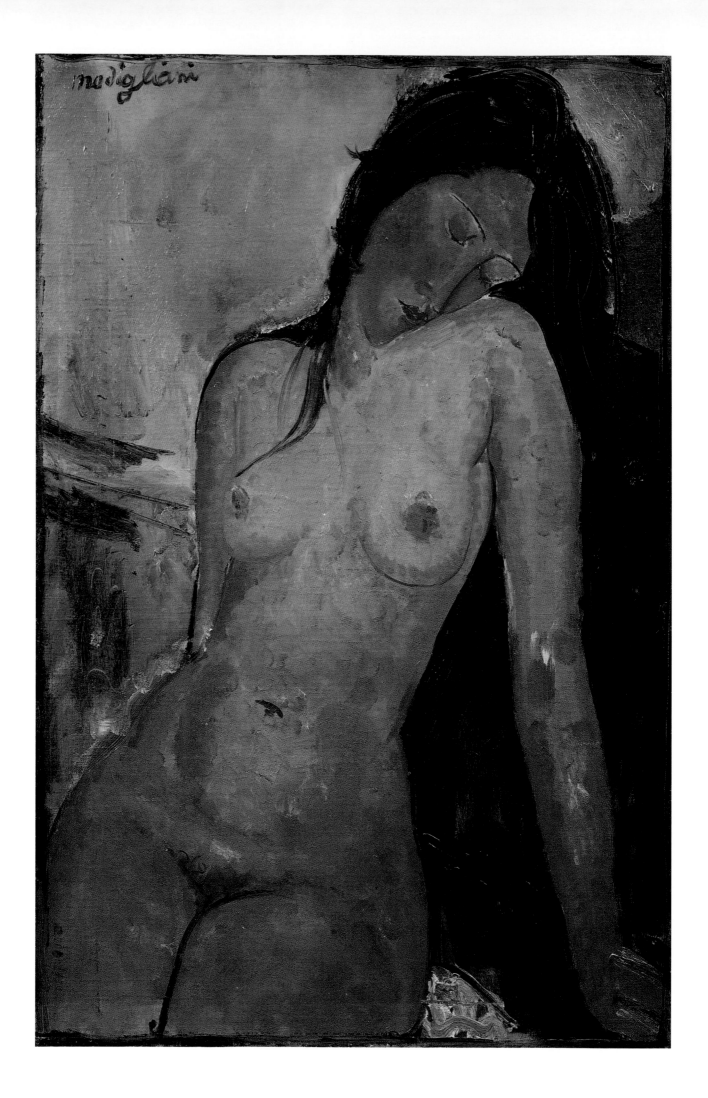

The Second Temple of Beauty

On Monday, December 3, 1917 a group of invited guests gathered in Berthe Weill's gallery for the opening of a Modigliani exhibition. It was the 33-year-old artist's first one man show and would remain the only one in his life-time. The presentation of roughly thirty drawings and paintings had come about through the efforts of Leopold Zborovski, who had been able to per-suade the committed art dealer, Berthe Weill, to put on the exhibition. She had just moved her gallery into new rooms on the Rue Taitbout, close to the Opera. It was Modigliani's bad luck that exactly opposite the gallery lay a police station, where the reason for the ever-increasing stream of visitors to the gallery was quickly noticed. Not only were a number of large-format nude paintings hung in the gallery rooms; for publicity purposes, one of Modigliani's elegant nudes had also been placed in the window. This was an attraction which caught the attention of many passers-by who stopped to take a closer look at the exhibition. This caused a small scandal which ended with the show being banned. Berthe Weill was called in to see the commis-sioner. "I crossed the street to the shouts and jokes of the crowd and climbed the steps to the police station", she later told Jeanine Warnod, author of the book *La Ruche et Montparnasse*. "The commissioner's office was full of 'customers'. 'You wanted to see me?' – 'Yes; I order you to take down all that filth.' I tried to reason: 'There are some connoisseurs of art who are not of your opinion [...] What is so bad about the nudes?' –'Those naked women! [...] They have pubic hair'. And he puffed himself up, spurred on by the approving laughter of the poor devils crammed into the building, and continued: 'If my orders are not carried out immediately, I will have every-thing seized by a squad of policemen.' What an idyll [...] Each policeman in the squad with a naked Modigliani beauty in his arms [...] I closed the gal-lery and the invited guests helped me to take down the paintings."

This censorship of his only one man show lends a curious tinge to Modi-gliani's biography. The very artist who strove for Renaissance beauty and ideals in his painting, distancing himself from all provocative avant-garde art, caused with his paintings an éclat seemingly custom-made for the Modi-gliani legend. Moreover, the story of the banned exhibition ideally reflects the dialectics of Modigliani's nudes. On the one hand, the paintings of medi-tative, introspective, naked young women are something divine. In the words of the art historian Giovanni Scheiwiller, they symbolise "a com-pletely spiritual unity between the artist and the creature he has chosen as his model". On the other hand, the appealing way in which the female body is presented did very much to further the idea of Modigliani the womaniser and Bohemian. Stories that Modigliani did not merely paint his models became a favourite motif, later fully exploited in novels and films. In André Salmon's Modigliani novel, for example, there are a number of such racy

Standing Nude, 1916
Pencil
Private collection

ILLUSTRATION PAGE 58:
Female Nude, 1916
Oil on canvas, 92.4 x 59.8 cm
Ceroni 127
London, Courtauld Institute Galleries, Samuel Courtauld Collection

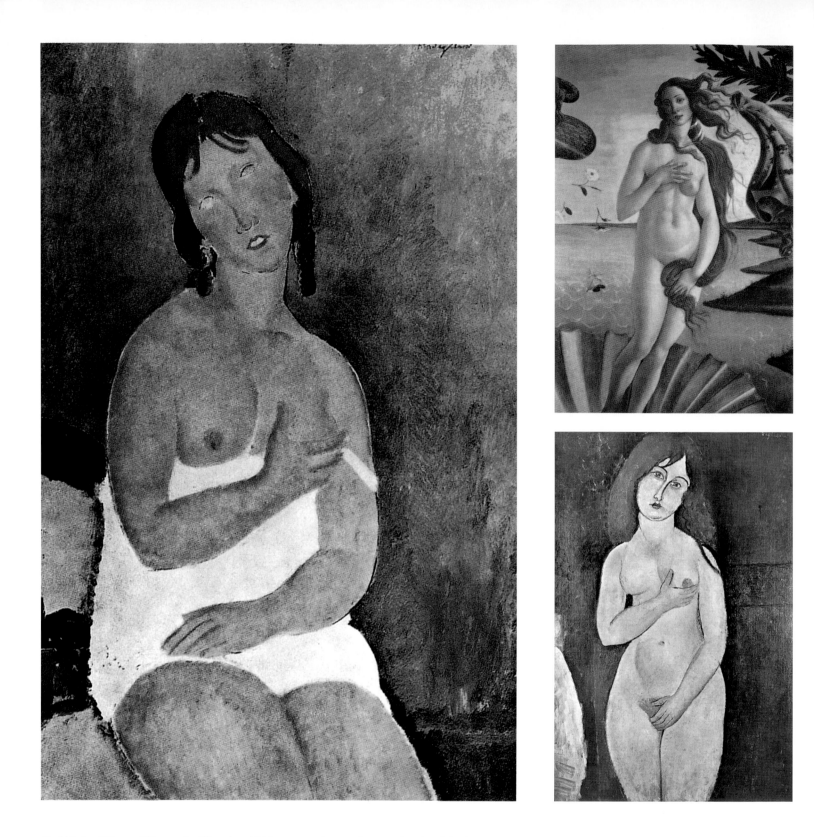

Red-Haired Young Woman in Chemise, 1918
Oil on canvas, 100 x 65 cm
Ceroni 265
Private collection

stories, often paired with the author's own peculiar wit. He invents a scene, for example, where Modigliani watches a model undressing in his studio and with every piece of discarded clothing and every new pose, he is reminded of other models in art history. Modigliani shudders both at the imaginary parade of authorities such as Edgar Degas (1834–1917), Pierre Bonnard (1867–1947) and Auguste Renoir and at the sight of the naked girl; he decides that he must first make love to her before he can achieve a completely personal mode of expression at the easel. In contrast to other, rather tiring passages in the book, here Salmon cleverly manages to draw a parallel between the eye of the man and that of the artist. The anecdote has grasped one of the essential aspects of paintings of nudes – the oscillating relation-

ILLUSTRATION PAGE 60 TOP RIGHT:
Sandro Botticelli
Birth of Venus (detail), 1482
Tempera on canvas, 172 x 278 cm
Florence, Galleria degli Uffizi

ILLUSTRATION PAGE 60 BOTTOM RIGHT:
Standing Nude (Venus), 1917
Oil on canvas, 100 x 65 cm
Ceroni 189
Private collection

Modigliani's nudes ofen cite models from art history. Although shrouded in mythology, Modigliani relieved his models of their historical aura and depicted them freely and erotically. In 1917, this led to the closure of an exhibition of his paintings of nudes.

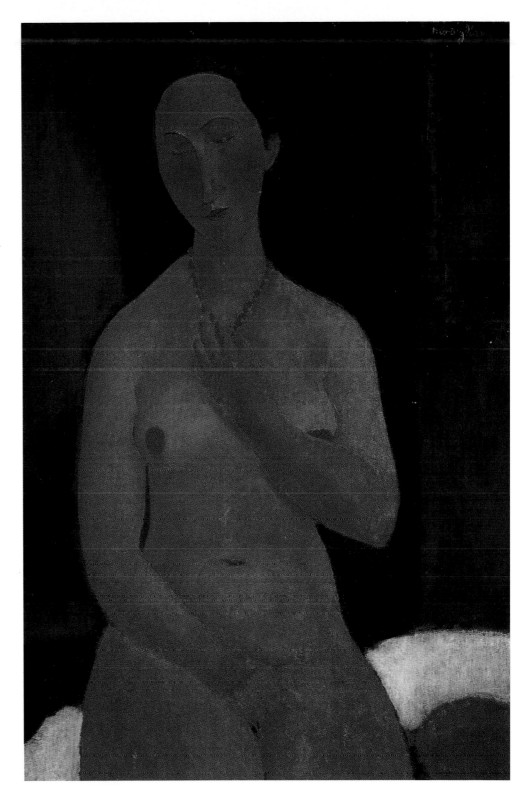

Seated Nude with Necklace, 1917
Oil on canvas, 92 x 60 cm
Ceroni 187
Private collection

ship between the unclothed object who is being portrayed and the reproducing artist.

Modigliani's nudes are therefore a more complex phenomenon than one would expect at first viewing. Their nature is such that the artist's idea and its rendering, the conditions surrounding the execution of the pictures, their historical context and later assessment can barely be separated from each other. And all of this is meshed with the image that one has made of the man Modigliani, of his character, his morality and his way of life. Of course, one should not judge an artist on moral criteria and then evaluate his work. In fact, as has often been pointed out, Modigliani's life – shaped by poverty, illness, alcoholism, drug-consumption and turbulent love affairs – had

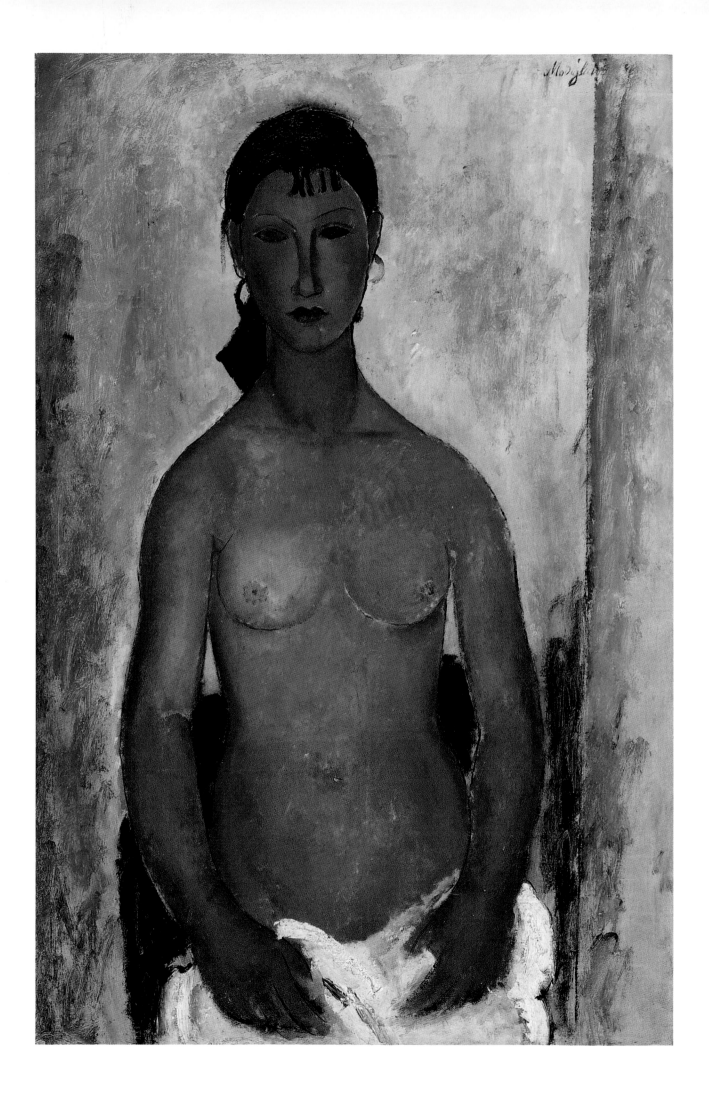

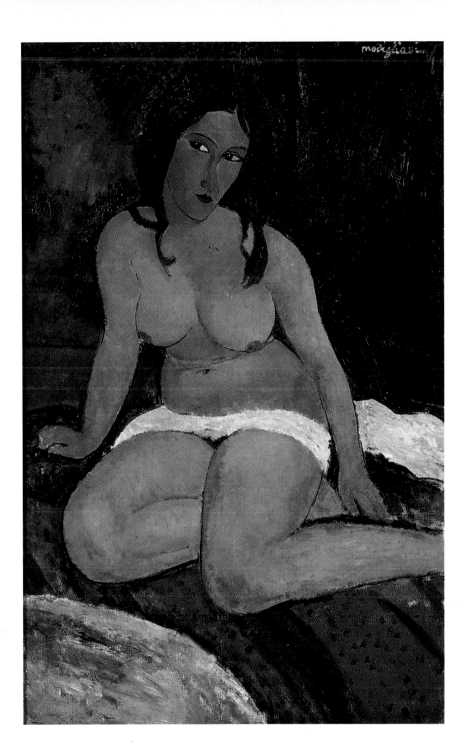

Seated Nude, 1917
Oil on canvas, 73 x 116 cm
Ceroni 188
Antwerp, Koninklijk Museum voor Schone
Kunsten

ILLUSTRATION PAGE 62:
Standing Nude – Elvira, 1918
Oil on canvas, 92 x 60 cm
Ceroni 272
Berne, Kunstmuseum, Gift of Walter and
Gertrud Hadorn

absolutely nothing to do with his work. Nevertheless, the Modigliani legend has always elicited at least as much curiosity as his pictures. Perhaps it is precisely this discrepancy between his immoderate life and his moderate work, so concentrated on form, that has led to the ever-growing interest in Modigliani in the course of this century. Yet it was and perhaps never will be possible to view Modigliani's pictures completely objectively. Whatever one chooses to think of him, the man Modigliani always played a role in the way his paintings were observed. And one is immediately struck by the deep divergence in these ways of seeing – particularly regarding the nudes.

It seems as if any assessment of Modigliani's nudes only allows for two extremes. Either one sees them as a mystery, as an expression of purity, as the uncovering of "all of the painful fragility of being" (to cite Scheiwiller once again), or one adamantly rejects them as late evidence of a delicate and mannered view of the human body, the last pangs of the fin de siècle and its degenerate cult of the woman as "femme fatale" or "femme fragile". Both

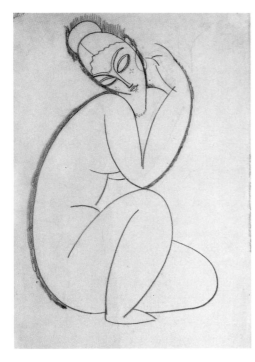

Female Nude, Kneeling on Left Knee
1911/12
Chalk on paper, 43 x 26.5 cm
Private collection

ILLUSTRATION PAGE 65:
Seated Nude on Divan, 1917
Oil on canvas, 100 x 65 cm
Ceroni 192
Private collection

assessments are *leitmotifs* in the literature on Modigliani, but neither can explain the reaction of the police commissioner on the Rue Taitbout, disturbed by the "pubic hair". At first this appears to be nothing more than the expression of a prudish moral view, but it is precisely this reaction which opens the way to an understanding of Modigliani's nudes. Modigliani's particular approach to the nude lay in his skilful mixture of a traditional subject with a specifically modern treatment of the female body, free of all prudery. The commissioner's response is an important historical reference not only to what was traditionally understood at this time as a nude study but also to Modigliani's special treatment of this tradition. Furthermore, the commissioner came straight to the point on how Modigliani had broken the rules. Finally, this response also indicates – and it is for this reason that it is of overriding importance – the small but very important difference between nude and naked.

The portrayal of the naked body as a subject in its own right, freed from allegorical or literary references, first developed into an independent genre solely within the academic tradition. Since the beginnings of the European art academies in the seventeenth century, life-drawing classes were offered as a part of the three-year course of studies. Art students were required to study drawing intensively. The first phase of study consisted in copying classical works in two dimensions; the second phase was devoted to copying plastic, i.e. three-dimensional works. It was only then that students could attempt to draw a live model, for the portrayal of human beings was considered to be the most elevated and difficult task for an artist. Within the drawing studios of these academies, it was expected that the binding canon of poses and positions be closely observed. The nude study is therefore a typical academic phenomenon, defined by strict, formal rules. It is no wonder, therefore, that throughout art history there were a number of revolts against this standardised method of portraying a naked person. As soon as a painter dared to break with the unwritten laws – which occurred whenever a hint of reality crept into the picture – there would be an uproar. When the portrayed beauty was not a Venus, but instead a lady well known at court, such as the *Maja Unclothed* (ill. p.68) by Francisco de Goya (1756–1828); when suddenly a naked woman appeared outside of a literary and allegorical context and even had the cheek to look directly at the observer, as with Manet's *Olympia* (ill. p.69), the public felt that its traditional way of looking at such pictures had been disturbed and, even more serious, that its moral sensibility had been insulted.

Such reactions are naturally closely linked to the contemporary understanding of morality and are subject to historical change. To come back one last time to the police commissioner on the Rue Taitbout: by forbidding Modigliani's exhibition, he gives us an impression of what an academic nude was generally held to be in 1917. With his reference to the pubic hair painted by Modigliani, he named that piece of reality which never usually appeared in an academic nude study, leading him to use the pejorative term "naked" when referring to the paintings. Apart from this, he could also have noticed a further feature which distinguishes Modigliani's portraits of naked beauties from academic studies – the positions and poses which Modigliani gives his models. Nothing that the academies understood as the proper way to paint nudes can be seen in these figures; neither proportions, anatomy nor movement.

At the time when Modigliani was painting his nudes, criticism by artists of the academic depiction of the naked body had just reached its zenith. Some years before, the Futurist, Umberto Boccioni (1882–1916), had proclaimed: "We are against the painting of nudes, for it is just as boring a sub-

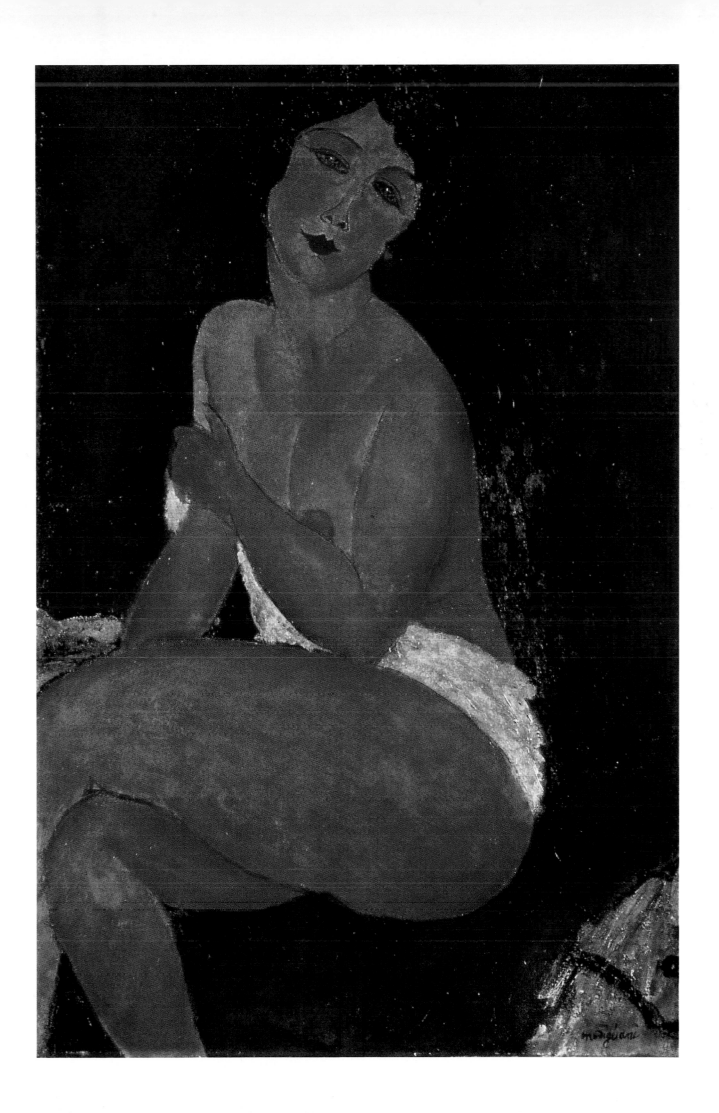

ject as adultery in literature." The body of criticism directed shortly before and after the turn of the century at the way in which the naked body was portrayed made clear that for artists, it was far from enough to show their subjects in traditional, unnatural poses. Instead, what was needed was a comprehensive reform of the image of man, and an art directed towards naturalness, vitality and subjective expression. When the German artists of the group *Die Brücke* – founded in Dresden in 1905 – went to the Moritzburg lakes with their models to paint in the freedom of nature, they thereby demonstrated a new, true-to-life understanding of art which had already been expressed by Gauguin. When Cézanne and then Matisse and Picasso took up the subject of bathers, depicting nudes in harmony with the surrounding nature, they were formulating the utopia of a free physical experience, something which can hardly be expressed more eloquently than in the title of Matisse's painting *Luxe, calme et volupté*.

Nude with Necklace, 1917
Oil on canvas, 64.4 x 99.4 cm
Ceroni 185
Oberlin, OH, Allen Memorial Art Museum
Oberlin College, Gift of Joseph and Enid Bisset

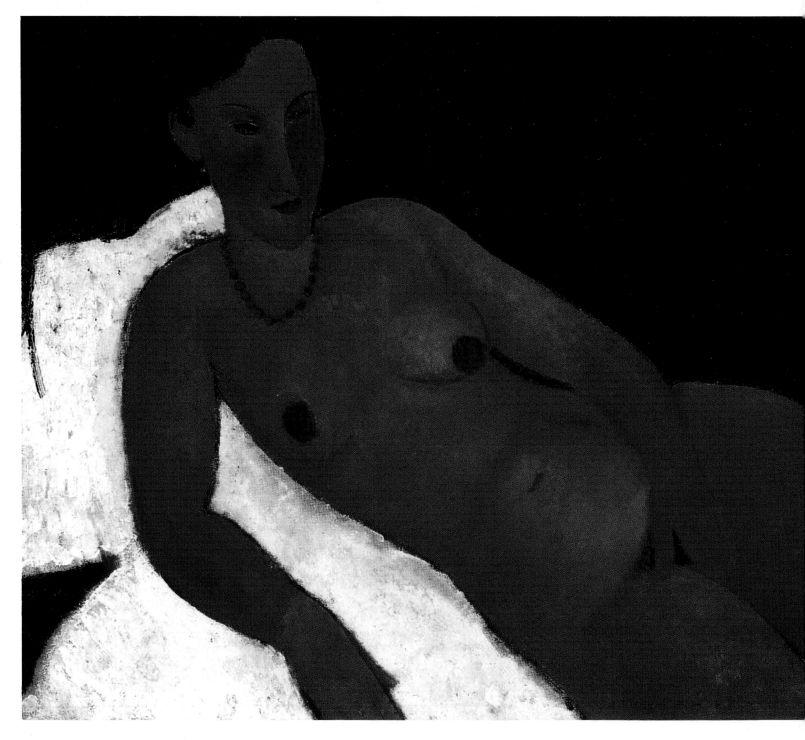

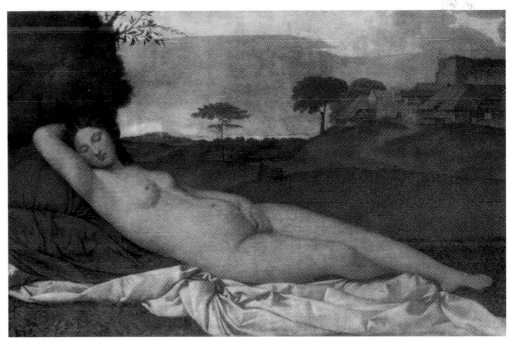

Giorgione
Sleeping Venus, c. 1508
Oil on canvas, 108 x 175 cm
Dresden, Gemäldegalerie

BOTTOM RIGHT:
Titian
Venus of Urbino, c. 1538
Oil on canvas, 118 x 167 cm
Florence, Galleria degli Uffizi

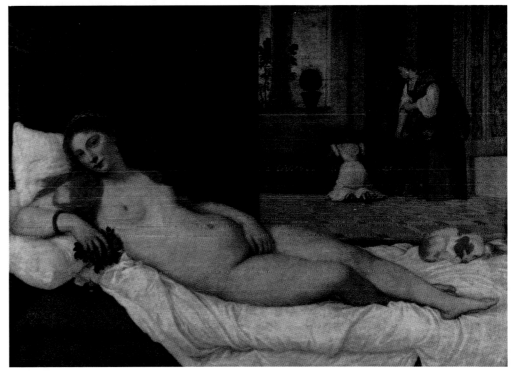

The case is somewhat different with Modigliani's "unacademic" nudes. While the words luxury, calm and sensuality could also be used to describe them, in formal terms Modigliani's nudes are much more closely linked than those of his French and German contemporaries to traditions within art history. In their technique alone, but also in their composition, his nudes betray a clear orientation towards the masters of the Italian Renaissance, towards Sandro Botticelli (1445–1510), Titian (1488/90–1576) and Giorgione (1477/78–1510; cf. ills. pp.60, 67). Modigliani thereby reached back to a pre-academic chapter of art history, to a time in which a naked Venus or Danae – to name only the most prominent models – were not rendered according to a catalogue of dictated poses. Instead, their composition was above all indebted to the iconography of an underlying history and the invention of the artist who portrayed them.

Modigliani, who never went to a state art academy, approached the por-

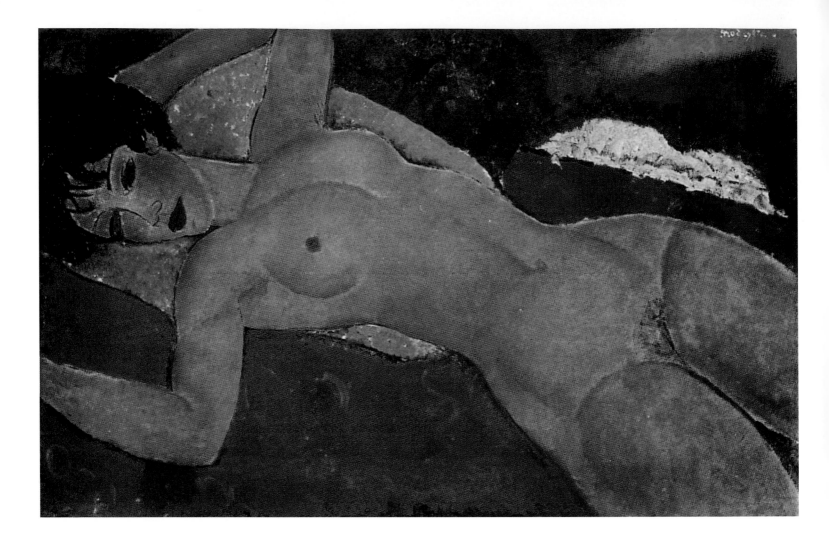

Francisco de Goya
Maja Unclothed, c. 1800
Oil on canvas, 97 x 190 cm
Madrid, Museo del Prado

TOP:
Sleeping Nude with Arms Open (Red Nude)
1917
Oil on canvas, 60 x 92 cm
Ceroni 198
Milan, Gianni Mattioli Collection

trayal of the naked body with an eye that was schooled more by art history
than by an academically-shaped perception of the nude. While he may have
learned the fundamental, academically-normed concepts of lifedrawing in
art schools in Florence and Venice, he may certainly be assumed to have
encountered alternative approaches to the study of the nude during his time at
the Académie Colarossi in Paris, where he enrolled in life-drawing classes in
1906 and 1907. The Académie Colarossi in Paris was one of the private
institutes, founded at the end of the nineteenth century, which offered a pro-
gressive alternative to the state academies. The special position of these aca-
demies in Paris, which also included the famous Académie Julian, resulted
from the fact that they also accepted students from amongst the many
foreigners living in Paris. The instruction consisted above all in providing
the students with models whose poses they could then determine them-
selves. Unlike the state academies, here one attempted to achieve more ani-
mated expressions. Rather than spending hours drawing one pose, the Aca-
démie Colarossi practised the so-called "fifteen-minute" nudes, where the
quick, sketch-like rendering of the pose was of primary importance. Many
drawings have been preserved from Modigliani's first years in Paris that
document his studies at these classes. In the clearly defined lines of the early
drawings one can already recognise the virtuosity of Modigliani's nudes of
1917. In these latter paintings, however, the movement and spontaneity of
the drawings have yielded to skilfully condensed compositions.

In Modigliani's portraits of naked young women one can observe the
same tendency towards ornamental stylisation as in his portraits. Once
again, it is the suggestive drawing of softly curved lines which sets off the

68

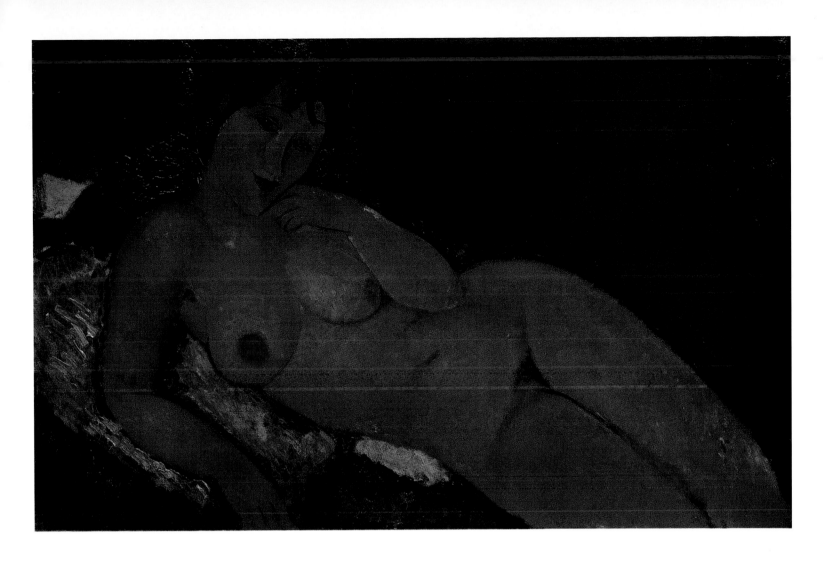

contours of the figures against the surrounding planes and which lends the paintings an elegant and delicate aura. Reduction and abstraction are Modigliani's main means of creation. Apart from a few summary details about the room surrounding the model – the outlines of a sofa, a cushion or a white linen sheet – there is nothing to distract from the young, rosy bodies. The sparing use of colour – usually the characteristic, apricot-coloured flesh tone of the nude contrasts with only one or two other tones – is evidence of the strong concentration on formal demands. The stylised forms of the female body are thereby provided with all the space they need for their effective exposure. The female figures present themselves to the viewer – are sometimes even lying in such a way – that they almost seem to tip out of the painting towards him; sometimes their wide eyes seem to be looking straight at him, and at other times they have closed their eyes, as if they are asleep. What catches the interest about Modigliani's alluring nudes – and this is another difference between his interpretation and academic nude studies – is their nakedness, their sensuality, their eroticism, their beauty. Modigliani's nude paintings are not about the depiction of naturalness and animation, as was the case with most of his contemporaries. It is much more that the stylisation of the depicted bodies lends the pictures grace, elegance and a high degree of artificiality. Modigliani's treatment of the nude subject even has something hermetic about it. In comparison to contemporary artists, it is noticeable that there is little connection between Modigliani's nudes and their historical context. On the contrary, if one recalls that by 1917 – as the injured and wounded returned home – the civilian population could no longer ignore the destructive

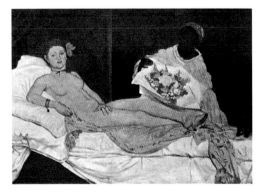

Edouard Manet
Olympia, 1863
Oil on canvas, 130.5 x 190 cm
Paris, Musée d'Orsay

TOP:
Nude on a Blue Cushion, 1917
Oil on canvas, 65.4 x 100.9 cm
Ceroni 146
Washington, DC, National Gallery of Art
Chester Dale Collection, © 1996 Board of
Trustees, National Gallery of Art, Washington

69

power of the war and that by this time Modigliani's own health was steadily worsening, the parade of rosy, healthy bodies awakens the impression that this is a determined counter-programme to reality. Completely in contrast to what he was experiencing in reality – the destruction of bodies – Modigliani expressed an artistic ideal and continued in his utopian quest for timeless harmony and beauty.

Modigliani's backwards-looking, idealising perception again accentuates his affinity with the Symbolists and the Pre-Raphaelites. His nudes are symbolic in their naked, physical presence; the mere existence of the bodies forms the crux of the picture, with background details uncharacterised and of little importance. And despite their carnality, Modigliani's nudes always have something sculptural about them. Even when they present themselves flirtatiously, and thereby sometimes remind one of the erotic photography that was so popular at the time, their sensuality is never aggressive, but is always restrained and coloured by melancholy. Modigliani's nudes are figures created by an artist. Their beauty emits a stony coolness and dignity. One could say that with this series of nudes – which he painted within a short span of time – Modigliani erected a second temple of beauty, for these paintings exhibit the same rapt sublimity as his carvings; their ideal beauty undergoes the same poetic transfiguration. Under Modigliani's lyric eye, the posing models become modern Venus figures, combining spirituality and liberality.

After his concentration on the nude in 1917, in the following years Modigliani only occasionally portrayed naked bodies. The nude *Elvira* (ill. p. 62), painted in the South of France in 1919, illustrates the brighter palette that was typical of this phase of Modigliani's work. The frontal presentation of

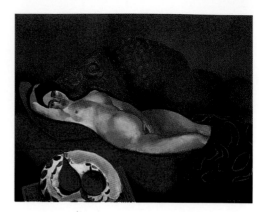

Moïse Kisling
Nude on Red Divan, 1918
Oil on canvas, 60 x 73 cm
Geneva, Petit Palais, Musée d'Art Moderne

Reclining Nude with Left Arm Resting on Forehead, 1917
Oil on canvas, 65 x 100 cm
Ceroni 194
New York, Collection, Richard S. Zeiler

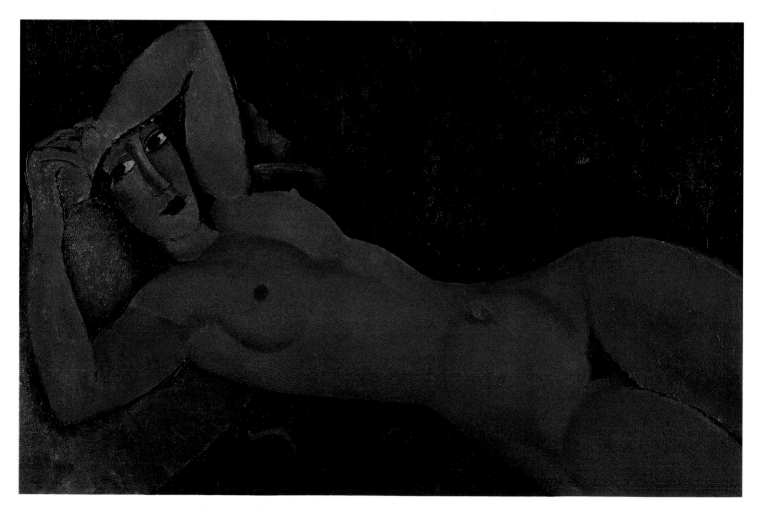

the standing model again highlights the importance of the sculptural in Modigliani's painting. Because Modigliani restricted himself to rendering the contours of the figure and to the painterly composition of the planes, the depiction of the person is condensed into the presentation of her pure existence, given permanency by the painting. Towards the end of his life, Modigliani managed to imbue many of the figures in his paintings with an expression that went beyond the purely individual. This is particularly evident in the portraits of anonymous models painted in the South of France. In these paintings, Modigliani's stylisation of the human being achieves its highest form.

Sleeping Nude, 1916
Pencil on paper
Private collection

Nude with Necklace, 1917
Oil on canvas, 73 x 116 cm
Ceroni 186
New York, Solomon R. Guggenheim Museum

Seductive beauty and sensuality, as well as artificiality and coolness, are features of Modigliani's reclining nudes. The cropped composition gives the viewer the impression that he is standing directly in front of the model.

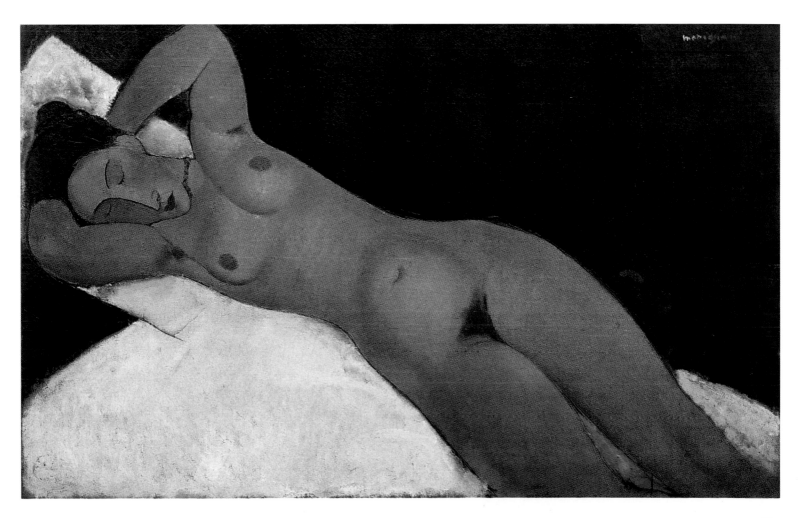

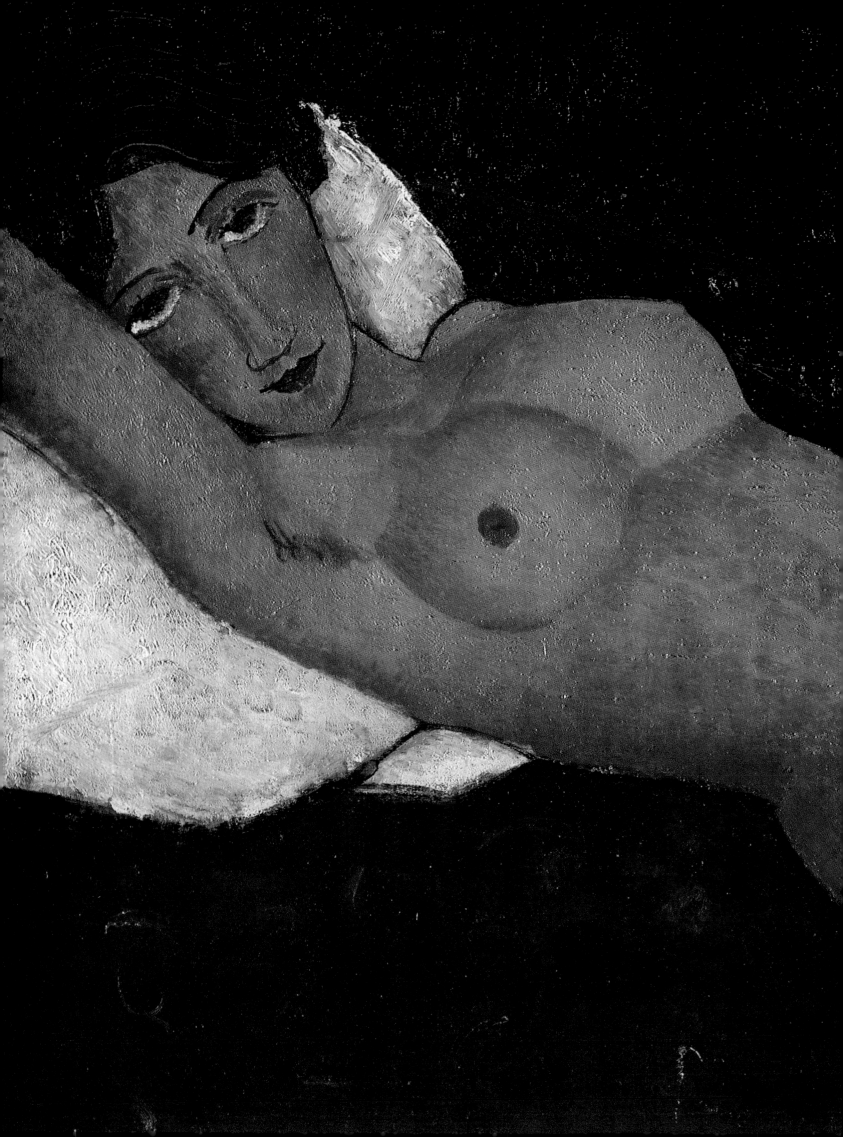

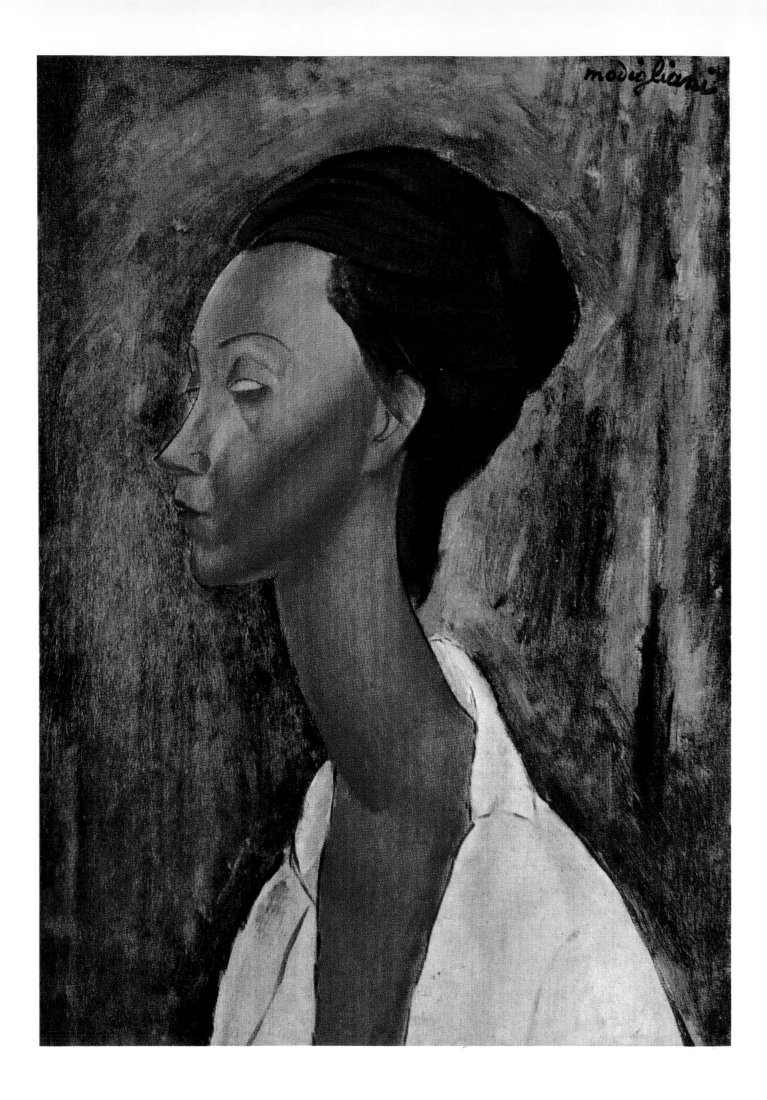

Nothing But a Mute Affirmation of Life

1918 was the fourth year of war. Food was in extremely short supply. Gas and electricity were rationed and the inhabitants of Paris had to learn to live with the terror of air raids. On January 30, the Germans bombed Paris with fifty fighter planes and caused inconceivable damage. In March, they began to move from the north-east towards Paris; the city was shaken by explosions and there were deaths among civilians. It was feared that there would soon be an advance made on the French capital. Evacuation measures began, and in April almost half a million people were on their way to the safety of the south.

Modigliani also left Paris in the spring of 1918. Together with the Zborovskis, his friend Soutine, and his new mistress Jeanne Hébuterne, he went to the South of France. Over a year passed before Modigliani returned to Paris, to spend the last months of his life there. In this year of turmoil at the end of the war, Modigliani painted like a man possessed. In the bright light of the Côte d'Azur he produced most of the paintings which would later become his most popular and highest-priced works. There are portraits of strong farm boys and thin servant girls, of sweet children and old grandpas, of worldly women and elegant men and, above all, there is always Jeanne. In the last two years of his life, Modigliani painted her no less than twenty-five times.

Modigliani's pictures from the South of France depict people who agreed to model for him. The anonymity of the majority of the subjects underlines a tendency towards the typical and general, a tendency which distinguishes these pictures from the portraits of the Paris years. The *Peasant boy* (ill. p. 86) is not really the portrait of an individual boy, portrayed in his uniqueness, but more a prototype country boy. This is demonstrated by the rejection of any anecdotal details referring to the boy's life and in the almost archaic rendering of his face. In Modigliani's Paris portraits, one can see that the artist had almost a caricaturist's eye for the physiognomy of his subjects; in these later portraits he is aiming for smoothness and stylisation. The pale blue of the open eyes harmonises with the other colours in the picture, which in its entirety emanates an agreeable calm and simplicity.

Indeed, Modigliani was never so close to his model, Cézanne, as here. If one compares Modigliani's technique in these pictures and their compositional outline, however, it is true that they do not have very much in common with Cézanne's pictures. As we have already seen, Modigliani's portraits develop out of drawing. This is also the case for these painterly, almost fresco-like paintings of peasant boys, which develop out of the unity of the softly rounded contours. Yet the motifs Modigliani chose for these pictures display the indisputable influence of Cézanne, perhaps sparked off by Modi-

Half-Length Portrait of a Young Girl (Jeanne Hébuterne), 1919
Pencil, 34.4 x 28 cm
Basle, Öffentliche Kunstsammlung
Kupferstichkabinett

ILLUSTRATION PAGE 72/73:
Reclining Nude, 1917
Oil on canvas, 60 x 92 cm
Ceroni 196
Stuttgart, Staatsgalerie

ILLUSTRATION PAGE 74:
Portrait of Lunia Czechovska, 1919
Oil on canvas, 46 x 33 cm
Ceroni 320
Private collection

Jeanne Hébuterne in carnival costume,
dressed as a Russian, 1917

A portrait of the art student Jeanne Hébuterne,
whom Modigliani met in April 1917. She was
the mother of his daughter, who was born in
Nice in 1918. Modigliani painted at least
twenty-five portraits of Jeanne. The portraits
executed in southern France are distinguished
by their increasing use of colour.

gliani's geographical proximity to the French painter's place of origin, Aix-
en-Provence. They confirm the high esteem in which Modigliani held the
Frenchman. Modigliani is said to have always carried around a reproduction
of Cézanne's painting, *Boy in a Red Waistcoat*, ever since visiting the Cé-
zanne retrospective in Paris in 1907, and whenever Cézanne's name was
mentioned, he would take it out and kiss it emphatically. Modigliani was
quite aware of his closeness to Cézanne. He is once supposed to have said to
Soutine: "Cézanne's figures, like the most beautiful statues of antiquity, do
not see. Mine, in contrast, do. They see, even if I have not drawn their
pupils. But like Cézanne's figures, they want to express nothing but a mute
affirmation of life."

The Russian writer Ilya Ehrenburg once described Modigliani's work as
the "great gallery of people", a homage to human existence. That might
sound rather dramatic, but the exclusiveness with which Modigliani devoted
himself to the portrait, as well as his concentration on rendering simple
human presence, does give rise to the fundamental question: what are Modi-
gliani's pictures actually about?

Alongside about four hundred drawings from the Alexandre Collection, a
note recently became public that Modigliani made in his sketchbook in
1907. "What I am seeking is not the real and not the unreal but rather the
unconscious, the mystery of the instinctive in the human race." Modigliani
wrote this on an otherwise empty page of his sketchbook. Noël Alexandre,
the son of Modigliani's Paris friend and patron, calls this statement Modi-
gliani's artistic credo. Modigliani's art, exclusively devoted to the human
portrait, aspires towards the creation of a realm beyond realism and symbol-
ism. Terms such as "the unconscious" and "the instinctive" were key con-
cepts for two intellectual movements which, at the beginning of this century,
would fundamentally alter our perception of man. These were the psycho-
analysis of Sigmund Freud and, probably far more important here, the philo-
sophy of life first expounded by Friedrich Nietzsche.

One of the most famous exponents of this philosophy was the Frenchman,
Henri Bergson. From various contemporary sources it is known that this
poet-philosopher was one of Modigliani's preferred writers. In his main
work, *Creative Evolution* (1907), Bergson's concept of "*élan vitale*" (life-
force) was his response to the rationalistic, deterministic understanding of
life. This understanding was vitalistic and dynamic and for the first time in
the history of philosophy did not rest upon a priori objective categories but
rather on the individual's subjective experience. According to the optimistic
view of Bergsonism, the individual becomes the creator of his own life. For
this philosophy, the experience of the self in time lies beyond all rational
premise. At the beginning of this century, this philosophy gave birth to an
entirely new understanding of man and existence and made a lasting im-
pression on many artists. One suspects that Bergson's concept of duration,
removing the way that man experiences time from accustomed mathematical
references, or his expositions on the "creative waiting" in which the develop-
ment of the self is carried out, had no small influence upon Modigliani. The
"instinctive", which was for Bergson the opposite of rational knowledge,
and the "mute affirmation of life" of which Modigliani spoke to Soutine, are
the first indications of the link between artist and philosopher. This link is
obvious in those Modigliani figures who seem to be beyond individuality in
their removal from all external categories and activities. The activity in
which they are portrayed can also best be described using a concept such as
"waiting". Turned inwards, Modigliani's figures sit with their hands folded
in their laps, gaze with heads bowed towards either the right or the left, have

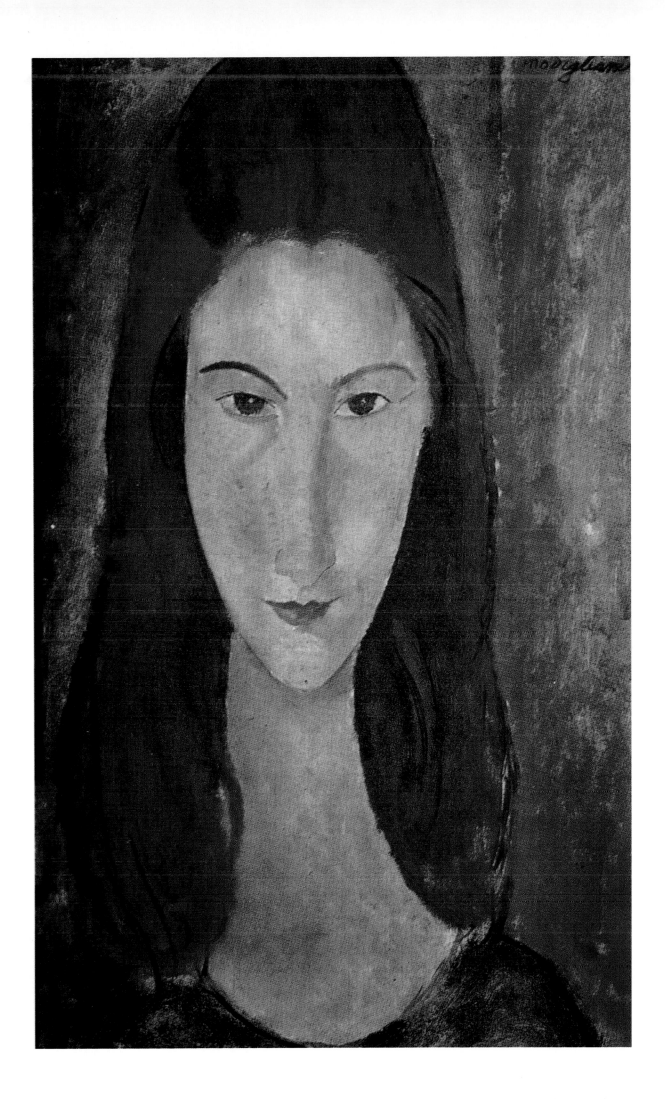

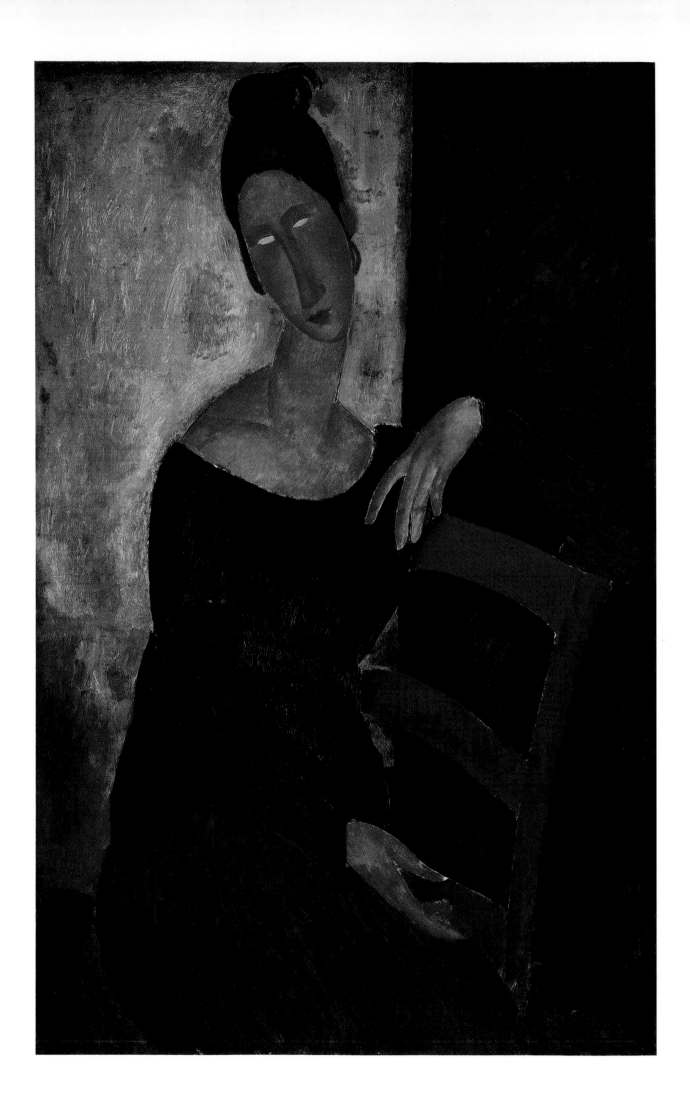

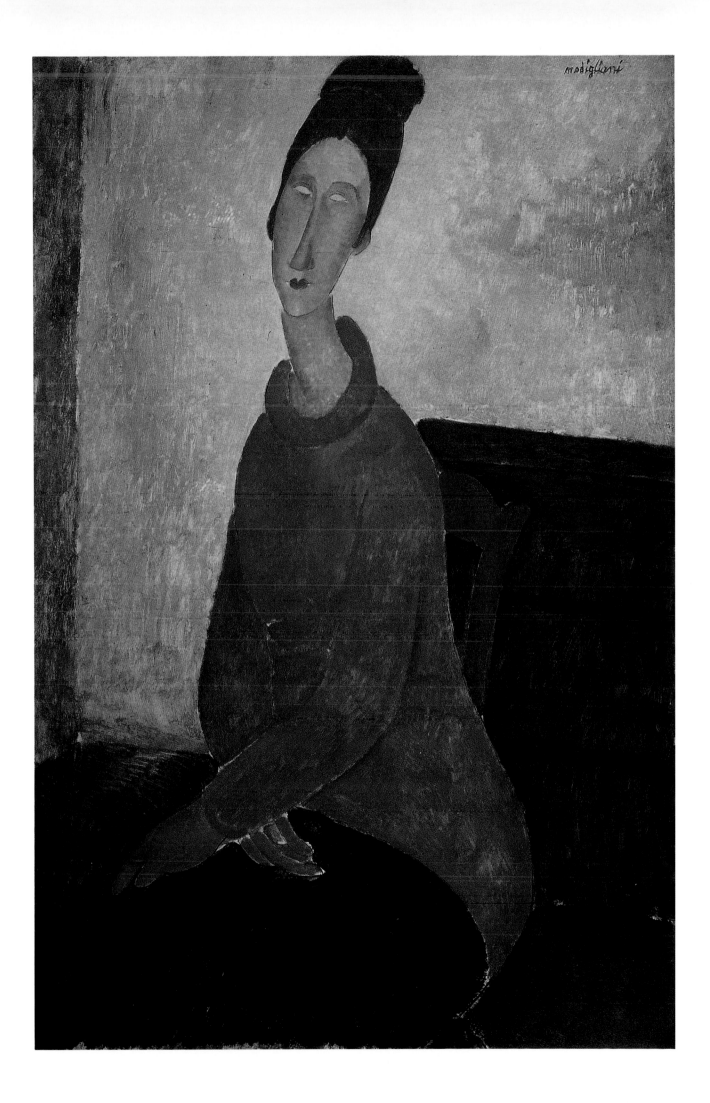

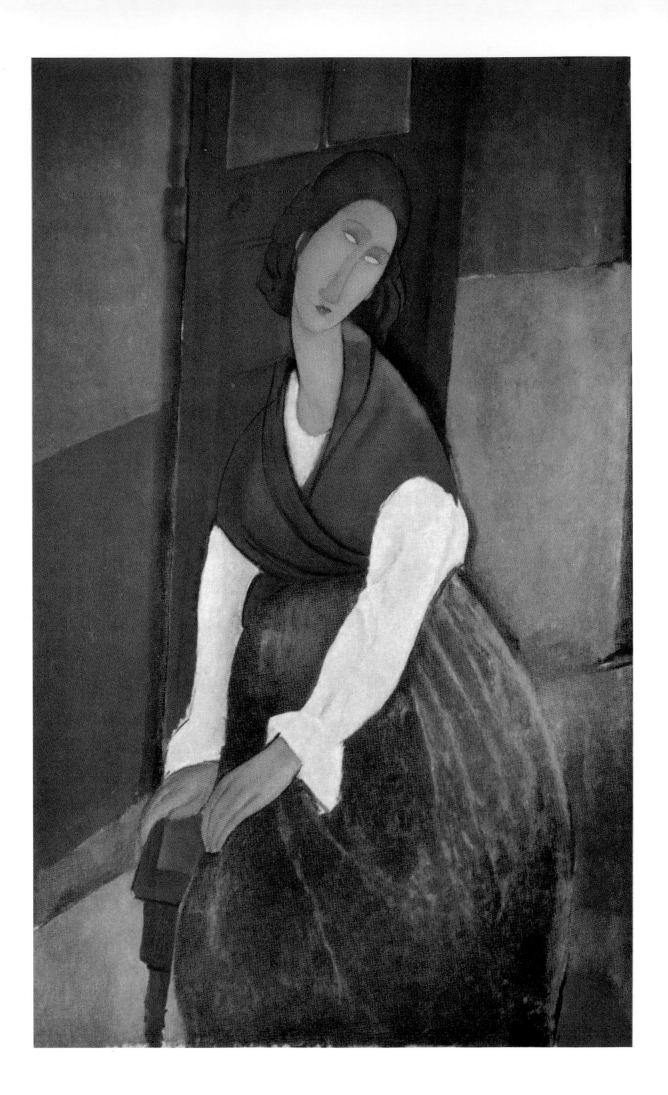

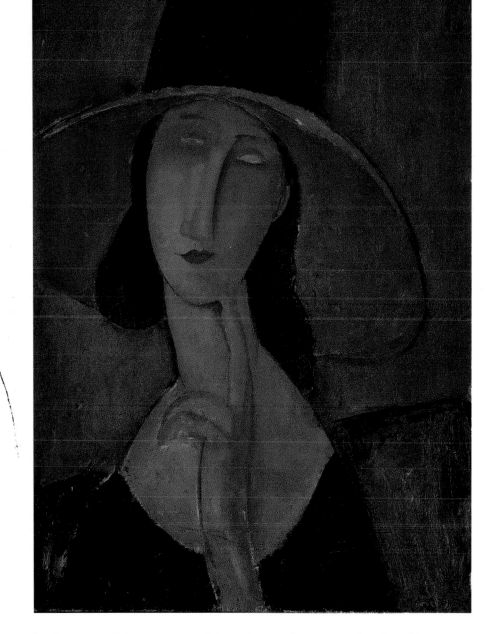

Portrait of Jeanne Hébuterne, 1917
Pencil on paper

TOP RIGHT:
Portrait of Woman in Hat (Jeanne Hébuterne in Large Hat), 1917
Oil on canvas, 55 x 38 cm
Ceroni 180
Private collection

ILLUSTRATION PAGE 80:
Jeanne Hébuterne, 1919
Oil on canvas, 130 x 81 cm
Ceroni 335
Los Angeles, CA, Mr and Mrs Sydney F. Brody Collection

time, are embodiments of the concept of duration and are completely withdrawn into themselves.

Modigliani's sojourn in the South of France also brought about a few stylistic changes. He used brighter colours; his brushwork became looser and the surface of his pictures less smooth than in earlier Paris years. Modigliani also tried his hand at landscapes on the Côte d'Azur, something he had last done as a very young man. The resulting paintings offered typical views of the region (ill. pp. 84, 85). Once again, the comparison can be made with Cézanne, but this time it is really only the Provençal motif and the palette which call up a similarity. In their treatment, in the contrast of softly rounded forms with static elements, Modigliani's landscapes recall more the work of André Derain.

There is almost no written documentation of the year that Modigliani spent in the South of France. Even his otherwise loquacious Parisian contemporaries knew too little about this period to be able to embellish it with details. Modigliani probably lived first in a hotel in Cagnes-sur-Mer and later moved even closer to Nice. It is here that Jeanne Hébuterne gave birth to a daughter on November 29, 1918. She was given the same Christian name as

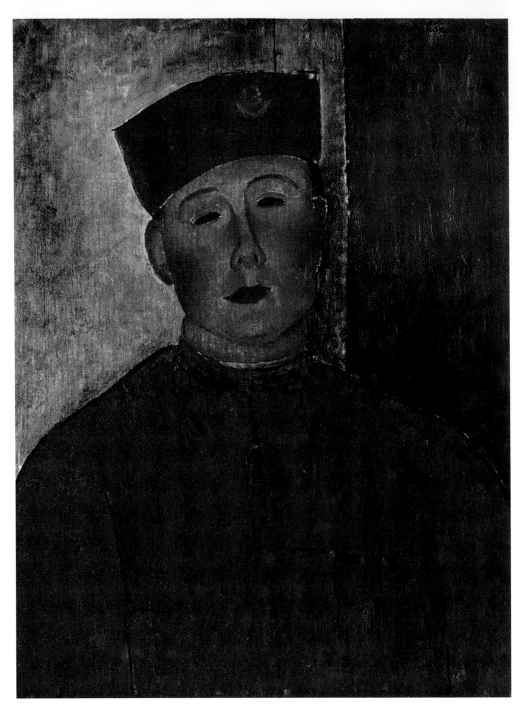

The Zouave, 1918
Oil on canvas, 63 x 48.3 cm
Ceroni 263
Private collection

Vincent van Gogh
Portrait of Milliet, Second Lieutenant with the Zouaves, 1888
Oil on canvas, 60 x 49 cm
Otterlo, Rijksmuseum Kröller-Müller

her mother. Modigliani's daughter was illegitimate but there is a document dated July 7, 1919, in which Modigliani promises to marry his fiancée, Jeanne Hébuterne, "as soon as the papers have arrived". Modigliani was not given enough time to carry out his intention. After the death of her parents in January 1920, the child Jeanne was raised by Modigliani's sister in Florence. Jeanne Modigliani, who died in 1984, wrote an important biography of her father, *Modigliani: Man and Myth*.

Although the months at the end of the war were not easy, Zborovski was able to sell several pictures by Modigliani and arranged to have his work shown at an exhibition in London. At this time, Modigliani also received support from the Finish-born painter of Russian descent, Léopold Survage (1879–1968), who let him use his studio. It appears that contact with Paul Guillaume was re-established in the South of France, for there is a photograph showing the rather dishevelled-looking Modigliani beside the elegantly dressed art dealer on the promenade in Nice. It is also reported that

ILLUSTRATION PAGE 83:
Man with Pipe (The Notary of Nice), 1918
Oil on canvas, 92 x 60 cm
Ceroni 288
Private collection

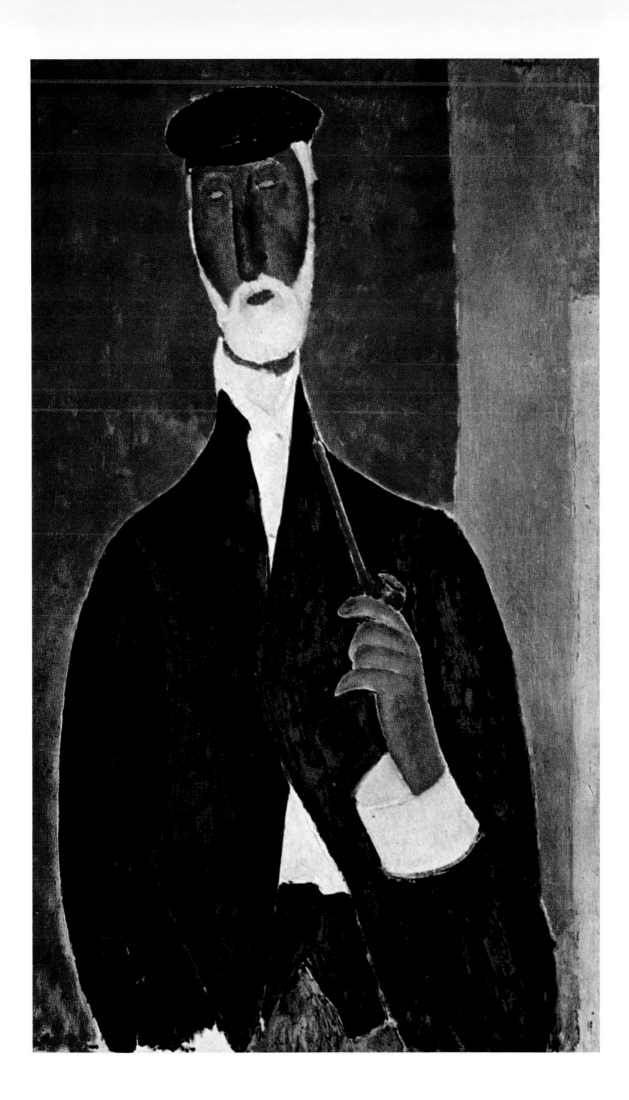

Tree and Houses, 1918/19
Oil on canvas, 55 x 46 cm
Ceroni 290
Private collection

In the spring of 1918 Modigliani left Paris, which was now threatened by invasion, and spent one year on the Côte d'Azur. This picture is one of a total of four landscape paintings executed by Modigliani in southern France.

Paul Cézanne
Vue du Château Noir, 1894–1896
Oil on canvas, 73 x 92 cm
Washington, DC, National Gallery of Art

ILLUSTRATION PAGE 84:
Landscape, 1919
Oil on canvas, 61 x 46.5 cm
Ceroni 293
Cologne, Galerie Karsten Greve

while in the South of France, Modigliani visited Auguste Renoir, who had a beautiful estate high up overlooking the sea. Whether or not this meeting between the doyen of Impressionism and Modigliani really ended in a clash – as reported by Renoir's neighbour, the painter Osterlind (1887–1960) – is only conjecture. The story goes that the elderly Renoir gave the young painter advice, telling him that one must paint with the same joy with which one made love to a woman. "Before I paint" Renoir is supposed to have said, "I caress the buttocks for hours." This elicited the response from Modigliani that he did not care for buttocks. He then left. As always, there is a kernel of truth in such legends insofar as this one marks out a fundamental difference between the Impressionist understanding of painting and that held by Modigliani. Renoir represents a style of painting which is derived from reality, is expressive and seeks to have a strong effect on the viewer. This was a style utterly rejected by Modigliani. The sensuality in Modigliani's paintings is of a different nature. It is more spiritual, lyrical and composed, most clearly expressed in the portraits of Jeanne Hébuterne that Modigliani painted at the end of his life.

"She was gentle, shy, quiet and delicate. A little bit depressive", was how the writer Charles-Albert Cingria characterised Modigliani's companion in his final years. Modigliani painted her lost in thought, removed from reality,

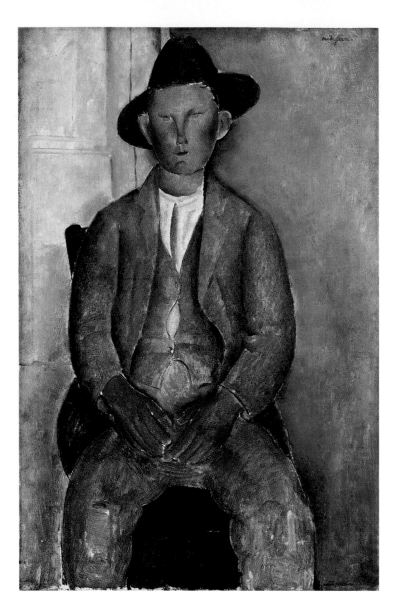

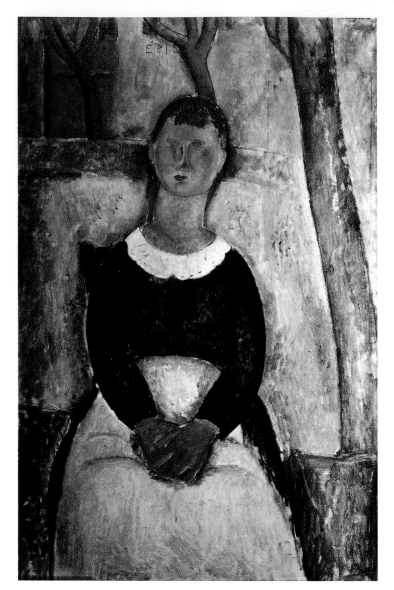

The Little Peasant, c. 1918
Oil on canvas, 100 x 64.5 cm
Ceroni 257
London, The Trustees of the Tate Gallery

TOP RIGHT:
The Beautiful Grocer, 1918
Oil on canvas, 99 x 65 cm
Ceroni 256
Private collection

time and place, and extremely beautiful. She was a young woman with reddish hair and pale skin; the almost stereotypical rendering of her face always reminds the viewer that she was painted by Modigliani. The fusion of painter and model, apparent in the portraits of his Paris friends, here reaches its most complete. Modigliani subjects Jeanne entirely to his style. In these pictures, he and Jeanne are one. Nevertheless, there is something anonymous about this mutual subjugation. In the same measure that Modigliani's painting style is always shaped by the same characteristics and thus appears objectified, the model becomes an icon of a person freed of all character and psychology. The only item of importance is the form, defined by long, elegant curves and yet still a body. When looking at the model, the viewer constantly has to decide whether this is a mere silhouette or its corporeal completion. This oscillating impression is heightened by Modigliani's use of colour. Applied in gradations, it defines rounded forms and lends the picture heights and depths, bringing linearity and volume into a balanced unity. Modigliani achieves the same harmonious effect in these portraits through the calculated juxtaposition of curvilinear and static elements. Modigliani always balances out any excess of large, sweeping curves by adding long, vertical or horizontal straight lines.

This use of contrast, whereby Modigliani shows himself to be a master of traditional composition methods, is intensified in these late pictures by an almost explosive palette. Modigliani had never before used such contrasted

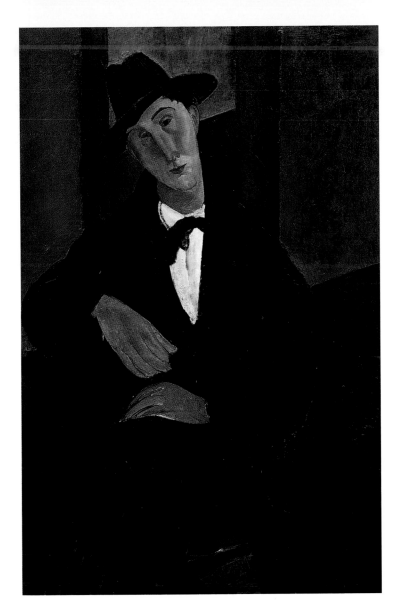

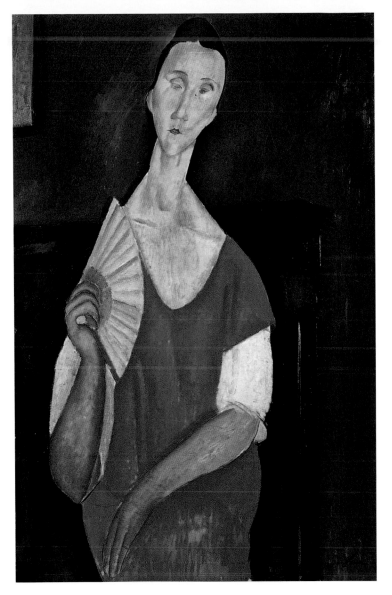

colours as primary red, blue and yellow, and the secondaries obtained from their mixture. The red of a petticoat against a pale-blue background, the yellow of Jeanne's long, turtleneck pullover, the violet of a skirt, the strong colour contrast between red and yellow in the portrait of Lunia Czechovska (ill. p.74), and especially the turquoise to emerald-green background of the picture of Jeanne in a white shirt (ill. p.92) – these all give an impression of how Modigliani was slowly turning into a virtuoso of colour. The colour contrasts that he thereby achieves are often harsh and cool. With his unconventional use of colour he avoids what would have been simply pleasing effects. He gives the quiet grace of his models a hint of eccentricity and thus completely removes them from reality, making them into artificial figures who only exist in the realm of the pictures. The emphasis on the artificial in art has its historical predecessor in Mannerism, which emerged in Italy in the sixteenth century as a counter-movement to the Renaissance. Several critics of Modigliani have described his work as mannered and established links to the tradition of Italian Mannerism.

Unlike the often puzzling, intellectual content of Mannerist pictures, however, Modigliani's works are purely visual and can only be understood by looking at them. They do not represent a new aesthetic theory, but rather are pictures of the people with whom Modigliani lived. Nevertheless, they do assume a knowledge of how the human countenance has been rendered throughout the history of art, for it is only in relation to this history that one

Portrait of Lunia Czechovska, 1919
Oil on canvas, 100 x 65 cm
Ceroni 321
Paris, Musée d'Art Moderne de la
Ville de Paris

TOP LEFT:
Portrait of Mario Varvogli, 1919/20
Oil on canvas, 116 x 73 cm
Ceroni 336
Private collection

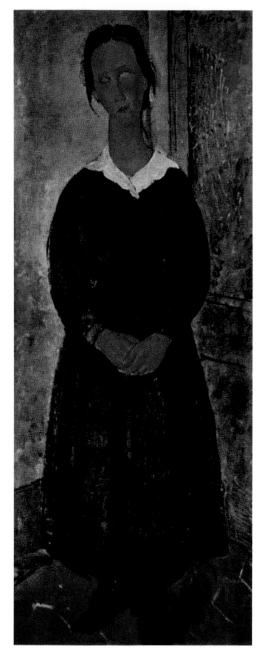

The Young Chambermaid, 1918
Oil on canvas, 152.4 x 60.9 cm
Ceroni 248
Buffalo, NY, Albright-Knox Art Gallery

ILLUSTRATION PAGE 89:
Young Girl, 1918
Oil on canvas, 92 x 60 cm
Ceroni 234
Paris, Musée Picasso

grasps Modigliani's uniqueness. Despite all subjectivity, his style strives towards objectification, anonymity, and duration. The abbreviated rendering of his models causes the observer to become so preoccupied with Modigliani's creation that he begins to think about the character of those about whom so little is revealed in the pictures. Faced with the isolation of the people in the pictures, he starts to raise questions about human existence. Modigliani does not even have the beginning of an answer. What he offers is a unified mood that exists in tranquillity, introspection and repose, and in his best pictures he succeeds in presenting this inner composure in a tautly-balanced form.

During his lifetime, Modigliani would continuously occupy himself with the depiction of the human form. But it was only shortly before his death in 1919, that he also painted himself in a self-portrait (ill. p. 6). The painting, executed in light, pastel tones, shows the painter sitting on a chair, dressed in a thick jacket, with a scarf slung around his neck. In his right hand he holds a palette, which contains the bright colours which distinguish his later pictures. His head is tilted slightly back and, judging from the expression on his well-proportioned face, he seems lost in reverie and unapproachable. Above all, however, it is again the eyes that play a decisive role in this impression of withdrawal. These eyes are neither open nor closed. What they perceive permeates in equal measure from both the outside and the inside; at one and the same time they represent subjective vision and orientation towards reality. In the painter's indifferent eyes is an expression of instinctive, unconscious observance which is utterly calm in the face of every distinction drawn between reality and unreality, for he is aware of his freedom to render this according to his own will.

The English art historian and novelist, John Berger, once noted that Modigliani's paintings are amongst the most popular of the twentieth century. According to Berger, this exceptional popularity, paired with a certain scepticism amongst art critics, has its roots in the fact that Modigliani's pictures are imbued with love and tenderness for the people depicted in them. One could add a further reason: at the beginning of this century, Modigliani still held fast to an intact image of human beings. It is an image determined by repose and freedom, by elegance and grace and sometimes also by melancholy. "Happiness is an angel with a serious face", Modigliani wrote on a postcard to his friend, Paul Alexandre, from Livorno in June 1913; this sentence expresses both the poetic and contemplative attitude of the artist. He certainly cannot be considered the "admirable painter of pain" for whom life would have been unbearable "without suffering as the source of the creative urge", as claimed by Gustave Coquiot and the artist Othon Friesz (1879–1949). Modigliani, susceptible to illness since childhood, lived a free and dissipated life and left behind a large and important body of work. Although sculpture was an important milestone in his development, his strengths clearly lay in painting and perhaps even more in drawing. He died on January 24, 1920, in the Charité in Paris from complications resulting from tuberculosis, and is buried beside Jeanne Hébuterne, who committed suicide the day after he died, in the Père Lachaise cemetery. A man of little success during his lifetime, Modigliani's fame – already becoming apparent at the end of his life – ironically escalated in the year of his death, and has steadily increased to the present day.

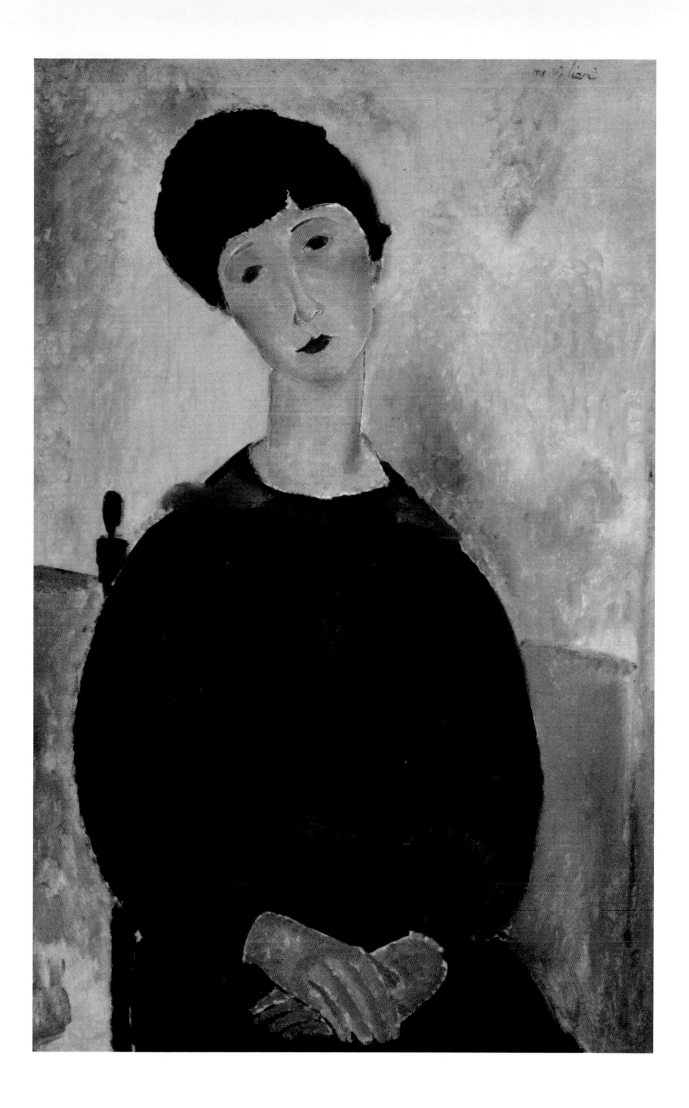

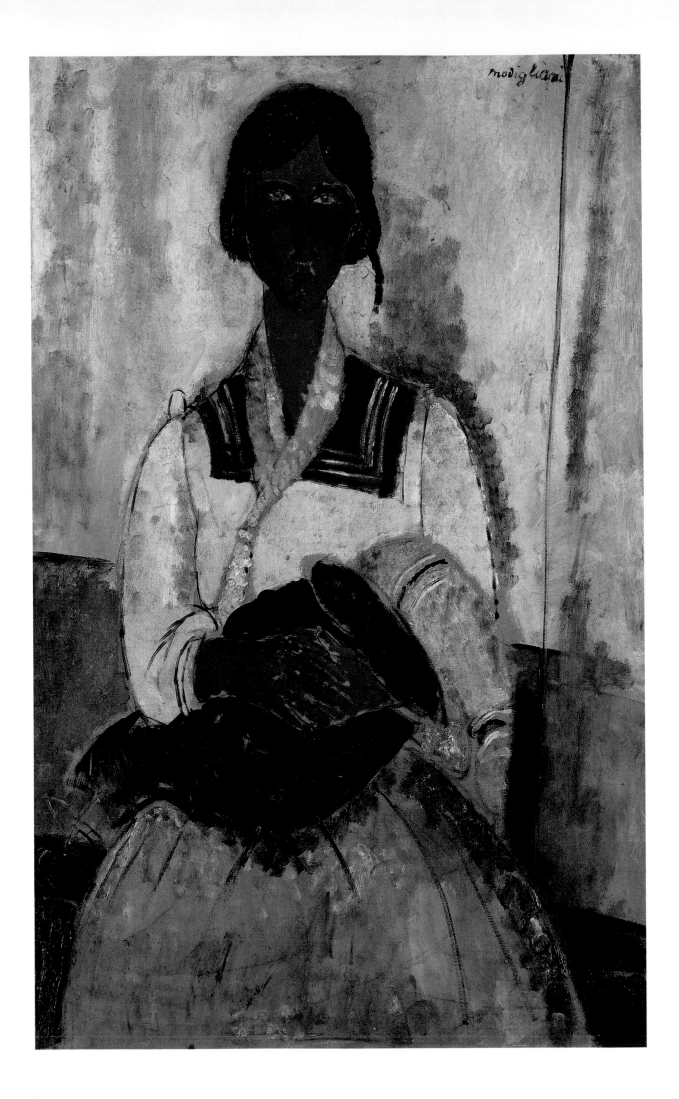

Seated Woman with Child, 1919
Oil on canvas, 130 x 81 cm
Ceroni 334
Villeneuve d'Ascq, Musée d'Art Moderne

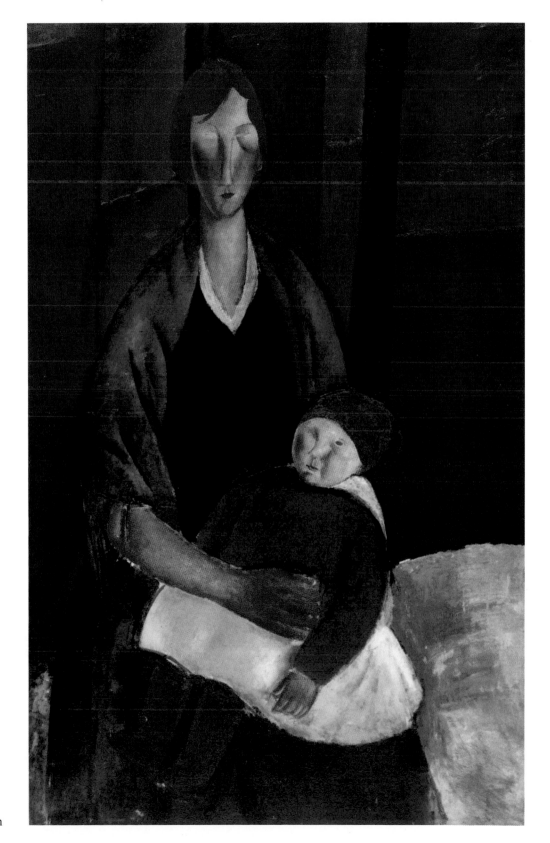

ILLUSTRATION PAGE 90:
Gypsy Woman with Child, 1919
Oil on canvas, 115.9 x 73 cm
Ceroni 247
Washington, DC, National Gallery
Chester Dale Collection, © 1996 Board of
Trustees, National Gallery of Art, Washington

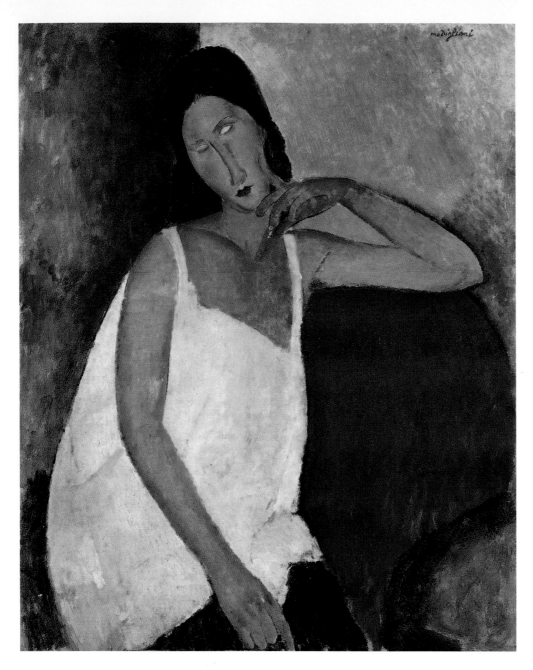

Portrait of Jeanne Hébuterne, 1918
Oil on canvas, 91.4 x 73 cm
Ceroni 326
New York, The Metropolitan Museum of Art
Gift of Mr and Mrs Nate B. Spingold, 1956
(56.184.2)

ILLUSTRATION PAGE 93:
Modigliani, c. 1906

Life and Work

1884 Amedeo Clemente Modigliani is born on July 12, the fourth and youngest child of Flaminio and Eugenia Modigliani, in Livorno (Leghorn), Tuscany. The family belongs to the more secularised Jewish bourgeoisie and at the time of Modigliani's birth is in a precarious financial situation. Because of an economic crisis in Italy, the family business goes bankrupt and in order to contribute to the family income Modigliani's mother begins to give private lessons and to take on translations. Modigliani grows up in an environment interested in literature and philosophy.

1898 Modigliani contracts typhoid fever and his destiny as an artist is revealed to him in a legendary delirious dream. After his recovery he leaves school and takes lessons from the painter Guglielmo Micheli at the Art Academy in Livorno. His brother Emanuele, who later becomes a famous representative of the Italian Socialist Party, is sent to prison for six months because of his political activities.

1900 Modigliani contracts tuberculosis and spends the winter of 1900/01 in Naples, on Capri and in Rome. Amongst his few remaining, written documents are the five letters that he wrote during this period of recuperation and study to his friend, the artist Oscar Ghiglia.

1902 On May 7 Modigliani enrols in the Scuola libera di Nudo (Free School for Nude Studies) in Florence and takes instruction with Giovanni Fattori. He visits Florence's museums and churches and studies the art of the Renaissance.

1903 Modigliani follows his friend Oscar Ghiglia to Venice, where he remains until moving to Paris. On March 19 he enrols in the Instituto di Belle Arti di Venezia and its life-drawing classes. In Venice's museums and churches he occupies himself intensely with the art of the old masters. At the Biennial in 1903 and 1905 he sees the works of the French Impressionists, sculptures by Rodin and paintings belonging to the genre of Symbolism. In Venice Modigliani becomes acquainted with the "joys of hashish" and is said to have taken part in séances. He befriends artists such as Ortiz de Zarate and Ardengo Soffici and will meet them again in Paris. Very few works exist from this period of Modigliani's studies in Italy.

1906 At the beginning of the year Modigliani goes to Paris. He moves into a simple studio on Montmartre and takes life-drawing classes at the Académie Colarossi. He makes the acquaintance of Maurice Utrillo, with whom he will remain friends throughout his life. In the autumn he meets the German painter Ludwig Meidner, who describes him as the "last, true bohemian".

1907 The painter Henri Doucet takes Modigliani along to the house on the Rue de Delta, which the young doctor Paul Alexandre and his brother have established to support young artists. Alexandre becomes Modigliani's first patron. He buys paintings and drawings from him and gets him commissions for portraits. Modigliani is probably represented with a few works in the autumn Salon. He visits the Cézanne retrospective and is deeply impressed. His paintings are

strongly oriented towards Symbolist models as well as the painting of Toulouse-Lautrec and Edvard Munch.

1908 Modigliani exhibits six paintings in the Salon des Indépendants, including *The Jewess*. Despite his poor health, he participates in the sensual, dissipated life of the artists on Montmartre. He moves house several times.

1909 In spring the portrait *The Amazon* is executed. It is Modigliani's first paid portrait commission. A rent receipt shows that Modigliani had a studio in the Cité Falguière on Montparnasse as of April at the latest. Through Paul

TOP:
Modigliani in his studio, c. 1918

BOTTOM LEFT:
Modigliani with his nanny in Livorno, c. 1885

BOTTOM RIGHT:
Modigliani, c. 1902

ILLUSTRATION PAGE 95 TOP:
Jeanne Hébuterne, Modigliani's companion

ILLUSTRATION PAGE 95 BOTTOM:
Modigliani in a bar on Montparnasse

ILLUSTRATION PAGE 96:
Seated Nude 1910/11
Chalk on paper, 42.5 x 26.4 cm
New York, Isabella del Frate Rayburn

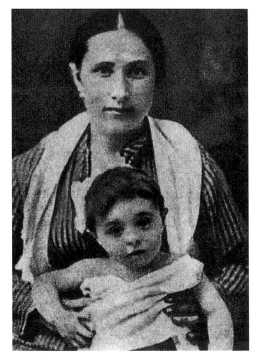

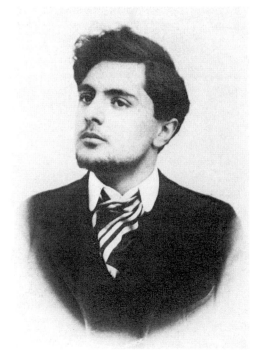

Alexandre he makes the acquaintance of the Romanian sculptor Constantin Brancusi. Modigliani spends the summer in Italy with his family, where his "health and cloths are restored", as he writes in a letter to Paul Alexandre. This is possibly the year in which Modigliani begins with stone sculpture, which for a time will take precedence over his painting.

1910 Modigliani exhibits in the Salon des Indépendants. He becomes friends with the writer Max Jacob and has an affair with the Russian poetess Anna Achmatova.

1911 Modigliani exhibits his archaic-like stone sculptures which he names "columns of tenderness" in the studio of the Portuguese artist Sousa Cardoso. Photographs of the exhibition show that the heads were illuminated and that they were presented as a "decorative ensemble". Idea for the erection of a "temple of beauty" to house the idol-like carvings. A phase of intense work on the motif of the caryatids begins.

1912 Modigliani makes the acquaintance of the sculptors Jacques Lipchitz and Jacob Epstein. His sculptures are exhibited in the autumn Salon. The English painter Augustus John buys a sculpture. By the end of the year Modigliani is once again living on Montmartre, Passage de l'Elysee des Beaux-Arts (today Rue Antoine).

1913 In spring Modigliani spends time in Livorno. He finds quarters near a stone quarry in Tuscany. In a letter he informs Paul Alexandre that he is now sculpting marble and is sending the finished pieces to Paris. Marble statues by Modigliani have, however, never been discovered.

1914 Through Max Jacob Modiglain meets the art dealer Paul Guillaume. In the next years he will lend Modigliani his support and include his work in a number of group-exhibitions at his gallery. In May/June Modigliani is shown at the exhibition "Twentieth Century Art" in the Whitechapel Gallery in London. In June he meets the eccentric English journalist, Béatrice Hastings. He will have a stormy love affair with her that lasts over two years; a period where she will be the preferred model for his portraits. When the war breaks out Modigliani is exempted from military service for health reasons. Paul Alexandre is drafted, ending the contact between him and Modigliani. Alexandre has a collection of approximately 400 drawings by Modigliani which are only made public in 1990. Modigliani begins to paint again and for the rest of his life will devote himself almost exclusively to the portrait.

1915 Modigliani paints a portrait of Picasso. He moves to Béatrice Hastings' flat in the Rue Norvain on the Butte Montmartre.

1916 Many portraits of famous contemporaries. A series of photographs taken by Jean Cocteau on August 12 shows Modigliani with Picasso, Max Jacob, André Salmon, Ortiz de Zarate and Moïse Kisling. In the autumn his work is shown in an exhibition in the studio of the painter Lejeune on the Rue Huygens. He meets the Polish poet and art dealer Léopold Zborovski, who will become his supportive friend. After breaking up with Béatrice Hastings, Modigliani moves out of their shared flat and begins to paint in Zborovski's flat in the Rue Joseph Bara.

1917 A series of roughly thirty paintings of nudes is executed. In April Modigliani meets the 19-year-old Jeanne Hébuterne who is studying at the Académie Colarossi. They move into a flat together on the Rue de la Grande Chaumiére. On December 3 his first one man exhibition opens at the Berthe Weill Gallery. The exhibition is already forced to close during the opening because of what is seen as the scandalous nature of the nudes.

1918 Because of the threat of invasion by German troops Modigliani and Jeanne leave Paris in the spring for the southern coast. In Nice and its environs Modigliani paints many portraits that he sends to Paris for Zborovski to sell. On November 29, 1918, a girl is born to Jeanne Hébuterne in Nice, who is recognised by Modigliani as his daughter. She is given the same Christian name as her mother. In December Paul Guillaume organises an exhibition in the Faubourg Saint-Honoré in which Modigliani is also shown.

1919 Zborovski arranges for several works by Modigliani to be shown in exhibitions in England. He is shown in Heale at the exhibition *Modern French Painting*, and in the Hill Gallery in London. English art collectors began to buy his paintings. At the end of May Modigliani returns to Paris. In July he signs a document promising marriage to Jeanne, who is pregnant again. He is shown at the autumn Salon. At the end of the year he becomes very ill with tuberculosis and a planned trip to Italy is cancelled.

1920 On January 24 Modigliani dies in the Charité in Paris. On the following day Jeanne Hébuterne commits suicide. There is a large crowd at their burial at the Père Lachaise cemetery. The child Jeanne is adopted by Modigliani's sister in Florence and later writes an important biography of her father. The first retrospective exhibition of Modigliani's work takes place in the Montaigne Gallery.

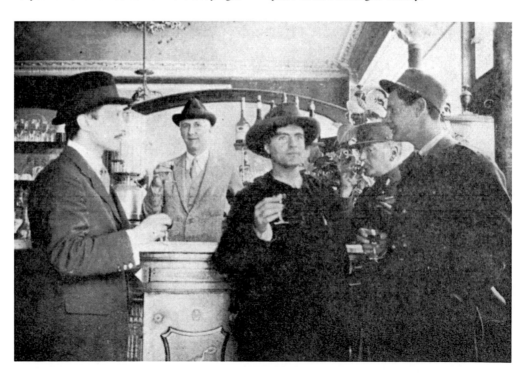

Modigliani